Ortega y Gasset

Velazquez, Goya and The Dehumanization of Art

Ortega y Gasset

Velazquez, Goya and The Dehumanization of Art

Translated by Alexis Brown

With an Introduction by Philip Troutman

W. W. Norton & Company, Inc. New York

Translation by Alexis Brown

EDITOR'S NOTE:
the editor wishes to thank Mr Philip Troutman of the Courtauld Institute for his invaluable help and editorial advice in the condensing and arrangement of these essays, and for his choice of illustrations.

The translation of this collection is © Alexis Brown, 1972
Published in the United States of America by W. W. Norton & Co. Inc.,
55 Fifth Avenue New York 3, N.Y.
Library of Congress Catalog Card No 74. 177440
Published in Great Britain by Studio Vista, Publishers,
Blue Star House, Highgate Hill, London N.19
Printed and Bound in Great Britain by W & J Mackay, Chatham
Set in Times New Roman 327 11pt 1½pt leaded

SBN 393-04358-4

Contents

Introduction

Here for the first time in English all the significant writings on art of the Spanish philosopher Ortega y Gasset are gathered together. The visual arts were only one of a variety of topics to which Ortega applied his highly individual, unorthodox approach. It was fundamental to his 'living' system of philosophy, that it should embrace all human activity, and part of the appeal of his discourses and reflections on any subject is that they are rarely narrowly confined. To Ortega, the understanding of any human activity could only be approached through a study of individuals in relation to their particular circumstances of time and place. A work of art was a part of the life of an individual; each brushstroke implied a human intention and action; and to understand a work of art, it was necessary to see the man, as it were, at work; to know his aspirations and intentions, and what his activity meant to him. The work of art could only be approached through a biography 'in depth' of the artist. To Ortega, indeed, the biography was the highest form of literature; but his idea of the biography was something very distinct from the traditional one. Whether or not we follow Ortega in his individual mode of approach, the thoroughness of his enquiry, and of his analysis and interpretation, has set an example that cannot be ignored.

Ortega was attracted to an investigation of the visual arts early in his career. It was an activity distinct from that of his own discipline as a philosopher, which demanded precise definition and exposition; in contrast, a painting, by its very nature, seemed to invite 'perpetual interpretation'. Reflecting upon the place of the visual arts in Spain, Ortega was struck by the fact that a country 'so little gifted for the visual arts', as its history has shown, should have produced two painters who, each in his particular age, were so in advance of any other artist that it is only more recently that we have been able to understand something of their essentially new approach to their art.

Of the two 'biographies', Velazquez' is the more searching and complete, and Ortega's reinterpretation of the artist's life and work forms the basis of much of our present-day knowledge and understanding of the artist.

Ortega's first task was, characteristically, to clear Velazquez' biography of the misinterpretations and contradictions that had accumulated and persisted through the ages and had in part taken on the character of facts – to Ortega, the most suspect 'fact' was that hallowed by tradition. Thus, Velazquez' comparatively meagre output – he was the contemporary of Rubens and Rembrandt – had been attributed to the demands

made upon the artist's time by the various duties extraneous to his art that he had to perform at the court of Philip IV. The apparently 'unfinished' character and 'hasty' technique of his paintings were explained in the same way. Ortega proposes the opposite to be the truth: that there was no painter with more time; and this becomes crucial to an understanding of Velazquez' painting. We know that Velazquez sought promotion at court outside his position as painter to the king, and possessed those aspirations to nobility to which Ortega attaches so much importance. Ortega arrived at his conclusion without, so it seems, any knowledge of the recently discovered correspondence between Cardinal Pamphili in Rome and the Papal Nuncio in Madrid, which discloses that Velazquez had sought the good offices of the Vatican to make known and further his desire to receive one of the noble orders. As it happens, the artist was made a Knight of Santiago in 1658. It is significant, too, that during Velazquez' prolonged second visit to Italy, from the end of 1648 to the middle of 1651, away from the demands and restrictive atmosphere of the Spanish court, he should have produced as little – this 'little' included, among other paintings, the portraits of his assistant Juan de Pareja and of the Pope Innocent X – as during almost any other comparable period of his career. We may now see as no more incongruous or prejudicial to his art the fact that the reflective Velazquez should have spent so much of his life within the walls of the Alcazar in Madrid, than that Rubens, of so different a temperament, should have spent so much time visiting the various courts of Europe on his diplomatic and ambassadorial missions. During his stay in Madrid on one such mission from 1628 to 1629, the Flemish master, with no more time on his hands than Velazquez had, found time to paint in the nine months of his stay no less than his Spanish colleague did in the same number of years. Among other things he copied all the Titians in the king's collection; and it is again significant that Velazquez, who was surrounded by these paintings all his life and was eventually to produce a painting equal in its freedom to that of the Venetian master, should never have made a single copy – with the exception of the *Rape of Europa*, which he introduced into his *Spinners* (plate 19), as a homage, it would seem, to the artist whose work he knew so well and admired. It is, incidentally, an indication of Ortega's deep understanding of Velazquez' painting, that his interpretation of the mythological subject-matter of *The Spinners* was to be confirmed shortly after his death by the discovery of a contemporary inventory reference to the Fable of Arachne.

In Ortega's analysis and reappraisal of the known facts relating to Velazquez' career, one fact presented itself to him as fundamental to an understanding of Velazquez' art: the artist's chance acceptance at the court of Philip IV at the very beginning of his career. In effect, Ortega

points out, Velazquez' career opens with his professional ambitions as a painter satisfied and his aspirations to nobility given promise of fulfilment. Velazquez did not have to consider the demands of clients; and indeed, the realization of his aspirations to nobility precluded the exercise of his art for gain. Henceforth, Velazquez painted for his own satisfaction; and we have to move to the nineteenth century to find an artist in a comparable position.

Ortega's interpretation of Velazquez' biography and his art – which he saw as an integral part of the artist's biography – brilliantly justifies his individual approach. His interpretation offers an answer to many questions that have been asked concerning Velazquez' position in relation to seventeenth-century painting: how, for example, he was able to achieve, as no other artist of the time, that living quality of presence, which may be seen as fundamental to the spirit and endeavours of Baroque art, while eschewing all the rhetoric, exaggerated movement and other characteristics of Baroque art; how, in the age also of realism, Velazquez could transcend all others in his representation of reality, while avoiding the representation of things; and how he did not need to learn any formulae or methods of painting from others, but could derive the meaning of his painting and its technique from his observation of and reflection upon the reality before him – for his brushstrokes do not describe or delineate things, but reveal them, much as light reveals things in Nature. We may recall Pacheco's injunction to his young pupil in Seville to trust Nature in everything: in his late paintings, Velazquez seems to have taken his master's precept to its logical conclusion.

In the case of Goya, Ortega dismisses out of hand the whole ¡of the artist's popular legend as without any foundation in fact. On Goya's death in exile in France in 1828, little was known of the man and it was impossible to begin to understand an art so individual and revolutionary. Accordingly, a fiction was made up of the man commensurate with the tremendous character of his productions, as the Romantic Age saw them, and his art was effectively ignored. The legend somehow persisted. Ortega sets the stage for a fresh analysis of the facts.

It was only late in his career that Ortega turned to a study of Goya, and accordingly he was able to investigate with thoroughness only a few of the problems presented by his new theme. He opened up, however, new and significant lines of enquiry. One of the most interesting and one of the first aspects of Goya that Ortega was to investigate, was that of the artist's supposed 'popularism', and his analysis of this eighteenth-century social phenomenon as it appeared in the second half of the century in Spain is an important contribution to Goya scholarship.

Ortega saw as fundamental to an approach to Goya the reconciliation of apparent 'opposites' presented by the artist's works: an impeccable

mastery of technique, and sudden displays of almost disdainful negligence; a quality of grace, and at times of grossness; an adherence to tradition and the norms of the time, and inexplicable bursts of unbridled fantasy; the Goya of *The Crockery-Seller* (plate 24) and the Goya of the 'Black Paintings' (plates 38 and 39). He sees the problem resolved in the answer to his question: how did Goya regard his activity as a painter? Effectively, Goya was a painter by profession, proud of his craft and the exercise of his almost boundless gifts; but he was also, 'on the margin of his profession', an artist, who from time to time would demonstrate sudden 'eruptions' of genius. To Ortega, the two activities were distinct in essence. We may not argue with the philosopher's terms of reference, nor with his conclusion, but we may ask if the problem exists quite as Ortega saw it, that is, that the trajectory of Goya's art was essentially erratic. Our present knowledge of the circumstances and chronology of Goya's works suggests that it was not; and it may not be out of place to present a brief survey of the facts as far as they relate to the problem. Ortega's juxtaposition of *The Crockery-Seller*, painted in 1778 at the very beginning of Goya's career, and the 'Black Paintings', painted nearly half a century later at the very end of his career, gives no more than the dimensions of Goya's achievement.

1776–1788 Goya was working on the cartoons for the Royal Tapestry Factory from 1775 to 1792, that is, much longer than Ortega supposed or could have known from the facts available to him at the time. Initially, the artist was working under the supervision of and following the designs provided by Francisco Bayeu, his brother-in-law and Director of Painting at the newly-founded Academy. In 1776, in accord with the growing interest in the popular, the subject-matter of the tapestries destined for the adornment of the royal apartments was changed from that of scenes of the hunt to that of representations of the 'costumes and diversions of the time'. We now know the sequence of execution of the tapestry cartoons and are able to follow Goya's gradual deviation from their essentially decorative and entertaining intention, as he makes the popular subject-matter his own and extends his observations of the popular scene. We may observe in these early works that 'rough and untutored, plebeian' quality, that Ortega perceptively sees as an important and integral ingredient of the artist's late paintings, and which, we may suspect, had something to do with Goya's early failures at the Academy. Through these years from 1776 to 1788 we may follow an expressive intensification of design in Goya's cartoons for the tapestries, which runs parallel with the intensification of the social atmosphere in Spain at the time and is consistent with Ortega's declaration that the artist was 'hypersensitive to the social atmosphere'.

10

1788–1798 Goya expresses in his correspondence in the years 1788 to 1792 his growing frustration with commissioned works which gave him little time for his own work. In 1792 he was to declare that art had no rules but depended only on the 'free exercise of the imagination'. Nevertheless, the impressive and monumental design of, say, *The Pick-a-back*, one of the cartoons he painted in 1791 and 1792, which anticipates the imaginative designs of the *Caprichos*, indicates how far he was able to incorporate his own art into his commissioned work at this stage of his career. It was at the end of 1792 that he suffered the illness that left him deaf for the rest of his life. During his convalescence in the second half of the following year he produced the series of small paintings – which include the *Interior of a Mad-house*, until recently confused with a later painting – in which, he tells us, he had been able to make 'observations that commissioned works did not ordinarily allow', and in which he had 'given his imagination free rein'. His illness relieved him of the demands of commissioned works for some five years, when he was able to devote himself largely to his own work, producing in 1797 the etched series of the *Caprichos*, whose subject-matter, derived essentially from an extension of his reflections upon the social scene and atmosphere, provided him a grand exercise in imaginative design. The introduction of witchcraft scenes, an extreme of the irrational, was no aberration in relation to the content of the *Caprichos*, which dealt with superstitions, ignorance, poor education, among other social ills, nor in the context of the times; and as 'material for the exercise of his imagination', as the artist declares in the advertisement for the *Caprichos*, it was absolutely appropriate. The decoration of the church of San Antonio de la Florida in the latter half of 1798, Goya's first royal commission as Painter to the Chamber since his illness, brings together in a monumental painting all that he had learned in the preceding five years. In spite of the fact that it was a commissioned work, Goya's interpretation of the religious subject-matter in popular and contemporary terms is entirely his own. It provides an early precedent for, say, the *Pilgrimage to the Well of San Isidro* or *Witches' Sabbath*, two of the 'Black Paintings'.

1798–1808 In 1799, Goya was nominated First Painter to the Chamber, and was engaged in that year and the following year on a series of royal portraits – including the well-known *Family of Charles IV* (plate 28). There would seem to be nothing erratic or inexplicable in the artist's career up to date. During the years to 1808, he appears to have been comparatively content to continue his public activity as a painter.

1808–1828 From 1808 to his death in 1828, Goya devoted himself increasingly to his own work. In any event, the War of Independence

11

deprived him of his royal patron for six years from 1808 to 1814. The war inspired his second masterpiece of etching, *The Disasters of War* (plates 33 and 34), and it was also in these years that he was to paint a series of works dealing, appropriately, with various aspects of man's violence, including, among other things, a series of small paintings depicting cannibals – including the well-known pair of paintings in Besançon (plate 29) which have their counterpart in the scenes of mutilation in *The Disasters*. On the conclusion of the war, Goya painted *The Second of May* (plate 35) and *The Third of May*; and after a short interlude of a year or so, when he was called upon, as First Painter to the Chamber, to make a number of portraits of the new king, Ferdinand VII – including that of the king presiding over a meeting of the Philippines Company – the artist was henceforth to work almost exclusively on his own painting. During the years of oppression and persecution introduced by Ferdinand VII's reign – a social outrage as great as if less overt and more senseless than the violence of the war – the themes that exercised Goya's imagination included, appropriately, those of men persecuted and deprived of their liberty and the series of drawings of nightmare visions. Removed from the context of their particular circumstances, the scenes of witchcraft, of cannibals and of nightmare visions could be seen as 'inexplicable eruptions of fantasy'.

Ortega no more than mentions the 'Black Paintings', the series of immensely powerful and individual designs with which Goya decorated his country house some time between 1820 and 1823, during a temporary, uneasy phase of constitutional rule in Spain. As the expression of the experience of a whole age of social upheaval, by an artist 'hyper-sensitive to the social ambience', the 'Black Paintings' cannot be seen as a sudden and unaccountable phenomenon, nor as anything else but a natural culmination to Goya's art.

Among Ortega's writings included in the present volume, his analysis of modern art, by the very closeness of the topic to us, will probably be found to be the most controversial and provocative of thought. The developments in modern art in the half century since Ortega wrote have confirmed much of the substance of his analysis. He starts from the 'fact' of the unpopularity of modern art, which is not unpopular in the way that any new and unfamiliar art may pass through an initial phase of unpopularity, but is unpopular in essence, in that it avoids all that the public has learned to expect to see in a work of art: its ability to represent and enhance things, its concern with human aspirations and destinies, everything, in fact, that seemes to constitute its *raison d'être* to an art-loving public, is scorned by modern art. To Ortega, the essential direction of the various manifestations of the new art of his day was towards 'dehumanization'. We might expect to find that Ortega was an enthusiast

for the new art, since much of his interpretation of it would appear to reflect his own approach: his mistrust of tradition, his concern for the 'art' element, that is, the 'unpopular' element, in a work of art. Ortega denies this, however, and declares that he is only moderately interested in the new sensibility and that he would not argue strongly against those who might say that the new art had produced little of significance. The new art of his day claimed his attention only because it was a fact; he wished neither to extol it nor to censure it, but only to try to understand it, 'as a biologist might analyse some new species'.

The visual arts are only one of a variety of topics investigated by Ortega, but it is the field in which his contribution has proved to be, perhaps, the most considerable and the least debatable. He was not an art historian. He was something different and something more. His incisive analyses cleared the ground for a fresh examination of the facts and opened lines of enquiry which have since been fruitfully pursued.

Philip Troutman

Three Bacchanalian Pictures
1911

Vino Divino

The arts of sculpture, painting and music, which seem so rich and bound-less, are in fact restricted to a cycle of recurring themes. Great artists do not extend the traditional stock of subjects: the dying man, the woman in love, the suffering mother, and so on. On the contrary, they show their aesthetic vigour in cleansing those themes of the coarse and trivial layer deposited by inferior artists, revealing once more, in its original simplic-ity, the iridescent jewel.

Thoughtless people imagine that human progress consists in a quanti-tative increase of things and ideas. Not at all: true progress is the grow-ing intensity with which we perceive the very few cardinal mysteries that pulsate in the shadow of history. Each century arrives equipped with a peculiar sensitivity towards certain of these great enigmas, abandoning the others as if forgotten, or at best approaching them awkwardly. Similarly, some men find themselves gifted with unusually sensitive vision, so that for them the world is a treasury of splendour and light – while at the same time they may be deaf to all harmony.

Thus, those basic themes can serve us as the confessions of history. For, when an interpretation is attempted each period declares its true character, the basic nature of its soul. And, if we choose a theme and follow the variations it has undergone in the history of art, we see un-folded before us the moral aspects of each age; aspects which come and go suffused with a quality that both gives them life and predetermines their end.

Strolling through the Prado Museum, under the warm white light which pours through the windows, I paused by chance before three paintings: the *Bacchanal* by Titian; the *Bacchanal* by Poussin; and *The Drinkers* by Velazquez. These three works by widely different artists each present an aesthetic solution to the tragi-comic theme of 'wine'.

Wine is of cosmic significance. You smile, but your smile gives assent. So significant is it that we today have not been able to ignore it, but approach it in a manner consistent with our own times. Thus we have seen it mainly as a problem of health. Associations, legislation, taxes, laboratory research . . . how much activity and concern has not been devoted to alcoholism?

Drink, I repeat, is of universal importance. I, too, smile: my mind has been shaped by the age in which I live, and reacts to the great secrets of

14

the world with conditioned responses. Yet our solution is symptomatic of the dullness of our age, its administrative hypertrophy, its morbidly cautious preoccupation with today's trivia and tomorrow's problems, its total lack of the heroic spirit. Who now has a gaze penetrating enough to see beyond alcoholism – a mountain of printed papers loaded with statistics – to the simple image of twining vine-tendrils and broad clusters of grapes pierced by the golden arrows of the sun?

But let us not be conceited: our interpretation of wine is only one among many, and is the youngest of them all. Once, long before wine became an administrative problem, Bacchus was a god, wine was divine.

We are creatures who pigeon-hole everything; we have got the world divided into boxes: each box is a science, and inside it we have locked the splinters of reality that we have been prising from the vast maternal quarry, Nature. And so, in little heaps assembled by chance or perhaps caprice, we hold the debris of life. In order to procure this lifeless treasure we had to dismember Nature, we had to kill her.

Ancient man, on the other hand, had before him the living cosmos, articulate and unfragmented. The principal classification which splits the world into things material and things spiritual did not exist for him. Wherever he looked he saw only manifestations of elemental powers, torrents of specific energies which both created and destroyed. The flow of water was not a succession of drops on drops: it was a way of life peculiar to the river gods. Day was a being with the magnificent task of periodically setting the fields on fire, and Night was a restorative force that brought the dead to life.

Well then: in that all-of-a-piece world wine appeared as an elemental power. The grapes seem swollen with light; condensed within them they store a wondrous force which takes possession of men and animals and leads them to a higher existence. The vine gives splendour to the countryside, makes eyes sparkle and teaches feet to dance. Wine is a wise god, fecund and dancing. Dionysus, Bacchus – they are the sound of perpetual revelry crossing the dense forests like a hot wind.

The Bacchanal by Titian

I do not believe there is a picture in the world as optimistic as this one. It shows a level stretch of ground adjoining a hill-slope. Some trees grace the spot; behind them, a sea of ultramarine, its waters dense and motionless. A ship slowly glides along.

The sky, of an intense blue, with a white cloud in the middle, plays the principal role; against it stand out the trees, the little hill, the arms and heads of some of the figures: all it touches is free from material troubles.

15

Men and women have chosen this peaceful corner of the universe to enjoy existence: they drink, laugh, talk, dance, caress one another and sleep. Here, all the biological functions appear dignified and with equal rights. Almost in the centre of the picture, a little boy lifts up his shirt and relieves himself. On the crest of the hillock a naked old man is sunbathing, and in the foreground to the right, Ariadne, naked and white, stretches out asleep.

This picture might have been given a more expressive name; it could have been called what in truth it is: the triumph of the moment.

We go through life tumbling from one instant to another; some of these are unimportant to us, and we let them drift by like a grey river flowing. Others bring us sharp sorrows, and all we can do is sigh and push the instant away from us; we would annihilate it if we could, so it would never return. But there are sublime moments in which we seem to coincide with all the universe; our soul expands and virtually embraces the horizon and we are one and the same with all that surrounds us, and we become suddenly aware of a harmony governing all things. This moment of pleasure is both the summit of life and its whole expression.

And then our spirit struggles to seize and hold the instant, or, rather, we fling ourselves into that instant as it swiftly passes, resolved to surrender without reserve or mistrust, as if the joyful moment were one of those lucky vessels that Homer attributed to the Phoenicians, ships that without pilot or rudder knew surely the pathways of the sea.

Titian has painted one such moment. These people live in a city and there they suffer the torments of material existence: they have insatiable ambitions, suffer privations, distrust one another, are grieved by the consciousness of their own limitations, and look at each other with fierce eyes. But one day they go into the country: the breeze is soft, the sun gilds the motes of dust in the air and makes blue shadows under the leafy branches. At this point someone brings amphoras and pitchers and slender jugs of silver and gold, delicately fashioned. Inside these vessels sparkles the wine. They drink. The hysterical tension of their minds relaxes: their pupils begin to grow incandescent, fantasies take shape in their cerebral cells. The truth is that life is not so calamitous, that human bodies are beautiful against a rural background of gold and blue, that the hearts of others are noble and pleasing, able to understand and respond to us. They drink. It seems as if invisible fingers were interweaving our being with earth, sea, air and sky; as if the world were a tapestry and ourselves figures in it, as if the threads which form our breasts continued farther still and were of the same fabric that make that distant cloud. They drink. How long have they been there?

Vaguely they remember that there is a city and there are sorrows, that things change, fade, and come to an end. It seems to them that they

16

have been here for centuries and will stay here forever, and forever a ray of sunshine will touch the curve of this silvery pitcher, scattering sparkles. Like an object of limitless elasticity, the moment has been stretched out and reaches from one side to the other of the hazy boundaries of time. This wish for eternal duration which lies at the bottom of every hour of pleasure has served Nietzsche in distinguishing the true values, the new tables of good and evil. Thus he says in the famous lines:

> *Sorrow says: Go!*
> *But Pleasure craves eternity,*
> *It wants profound eternity.*

As they drink, these people have been taking off their clothes so as to feel the caress of the elements on their warm skin, perhaps from a secret impulse and desire to merge more closely with Nature. And scarcely have they drunk than they perceive with a rare clairvoyance the ultimate secrets of the cosmos, the creative modulations of all things. These mysteries are rhythms. They see that the scene is a mass of blue tones – sky, sea, greensward, trees, tunics – to which the warmer tones, ruddy and gilded, respond – virile bodies, golden bands of sunlight, the bellies of vases, the glowing flesh of the women. They see the sky as an immense and subtle question; the earth, broad and strong, as a satisfactory and well-founded response. They see that in the world there is a right side and a left, a high and a low; they see there is light and shade, stillness and movement; they see that the concave hollows to receive the convex, that the dry aspires to the moist, the cold to the ardent; that silence is a prepared habitation, like an inn, for receiving transitory noise. . . . These people have not been initiated in the rhythmic mystery of the universe by any external study; wine, who was a wise god, has given them a momentary intuition of the greatest secret of all. It is not a case of certain concepts being introduced into their brains; on the contrary, wine has brought about the immersion of these bodies in the fluid reason in which the world is floating. And thus a moment arrives in which the movements of their arms, bodies and legs become rhythmic too, in which muscles do not merely move, but move in harmony. Motion is an occult logic that lies in the muscle: wine is the power which turns movement into a dance.

The Bacchanal by Poussin

Thus wine, according to Titian, carries purely organic material to a spiritual potency. Here, in his resplendent picture, we have the whole philosophy of the Renaissance, symbolized by figures who are all taking

pleasure around a few amphoras of wine. The Middle Ages speak to us of the spirit as the enemy and opponent of matter. By overcoming the latter, the former grows; life is a war waged by soul against body, its tactics being called asceticism. But the Renaissance senses the unknown quality of existence quite differently. It resists and denies this pessimistic duality. The world is one: it is not merely gross matter, nor is it merely imaginary spirituality. What is called matter can attain a rhythmic vibration – and this is what is called spirit. Of its own accord, or at most with the help of wine, the muscle arrives at dancing, the throat achieves the song, the heart attains love, lips find the smile and the brain the idea.

We can thus arrive at a formula expressing the meaning of the Titian-esque *Bacchanal*: it is the point of no distinction between man, beast and god. His people are of flesh and bone; by the mere intensification of their natural – that is to say animal – energies, they arrive at the essential union with the cosmos, at infinite intuition, at the absolute optimism which was the patrimony of the supposed divinity.

We will briefly compare Titian's painting with that of Poussin. The picture is a ruin: no photograph or engraving can possibly give an idea of it. There, in a scarcely-visited hall of the Museum, it lingers on in fatal agony.

The pure red tones with which Poussin painted his figures have been absorbed by the fierce sunlight which has been acting upon them for centuries. The cool tones, the blues mixed with black, stand out thickly. Before Titian's picture we laugh, but this physically-damaged canvas invites us to mourn, to meditate on the evanescence of all splendour, and on the cruel mission of time.

Nevertheless, what Poussin has to tell us is even more joyful than Titian's anecdote. For Titian relates nothing but an anecdote, he presents us with something essentially momentary. We cannot help observing the exertion of matter necessary in order to rise briefly, impelled by wine, to the fine spiritual vibrations; we cannot avoid the foreboding that all will end in an immense weariness, in jaded flesh and flaccid muscles, in a nasty taste in the mouth.

The figures in Poussin's picture are not men, they are gods: fauns, nymphs and satyrs, who forever accompany the impetuous progress of Bacchus and Ariadne through the woods. The realistic element – human and only human – of Titian is missing here. Not by default, not by error or forgetfulness, but deliberately. Poussin is painting at a time when the Renaissance itself has passed by like a human bacchanal. He is living in the morning after the Titianesque orgy, he weeps from weariness and disillusionment. The optimistic promises of the Renaissance have not been fulfilled. Existence is harsh and void of poetry; life is becoming narrower and narrower. The peoples of the West abandon themselves to

mysticism or to rationalism. What is there to live for? Let us suppress action where possible; let us reduce life to the minimum; rather than dwell on this present harshness, let us remember the splendours of a hazy past.

Poussin is a romanticist of classical mythology. He shows a harmonious group moving through an unreal landscape; divine beings, endowed with irrepressible laughter, who drink without getting drunk and for whom the bacchanal is not a revel, but normal life. Meier-Graefe has noted this very acutely: 'The Bacchanal of Poussin avoids all extremes. It is not, like Titian's, an episode in a day's licentiousness: it is bliss made normal.'*

We find the child of Titian's picture here, on the right, in a group formed by a faun and a nymph who is riding a he-goat. The boy, with his goat's feet, is a pretty little satyr, perhaps the son of the buck and the beautiful goddess. This drawing together of god and beast has that serious melancholy which is characteristic of Romanticism. When Rousseau postulated the return of man to nature he was also proclaiming the breakdown of civilization. This, the specifically human, is an error, a blind alley: the natural is more perfect than the artificial state; that is to say, the beast is closer to God than the man. And Pascal too, had earlier preached: *Il faut s'abêtir.*

The Drinkers by Velazquez

Beauty and happiness are attributes of the gods – suggests Poussin – not of men. The joy he describes in his picture produces a bitter reaction in us, because we feel excluded from it. Reality is arduous and a place of sorrow; joy is unreal, like these gods and nymphs. The sunlight has taken its revenge and darkened the picture, as they say the Olympian powers blinded Homer to avenge the dishonour he had cast on Helen.

Poussin's interpretation induces in us a contemplative mood, inward and hushed, in which we pick up tenuous echoes of that unquenchable laughter from the lips of the gods. It is an interpretation offering little comfort, an equivocal invitation to a lasting melancholy. But, at least, Poussin assures us that there are gods. Poussin paints gods.

And here we come to Velazquez, who gets together a few rough labourers, a few rogues, the dregs of the city, dirty, cunning and idle. And he says to them: 'Come on, let's go and poke fun at the gods.'

In the middle of a vineyard he strips a burly, flabby-fleshed fellow and twists some vine-leaves round his head. This one shall be Bacchus.

* It was this phrase of the German critic, in his *Viaje en España*, that prompted me to write this essay.

And he groups the rest of them round a jug and lets them drink till their eyes bulge with stupidity and their cheeks contract in an idiot grin. This is all.

The bacchanal descends into drunken debauch. Bacchus is a fraud. There is nothing more than what you can see and touch. There are no gods.

The state of mind that this reveals, the mockery of all mythology that is apparent throughout Velazquez' work – for example his *Mercury and Argos* or *Mars* – has without doubt its own grandeur. It is a courageous acceptance of materialism, a challenge to the cosmos, a superb *malgré tout*. But can this be justified? Is not realism itself a limitation?

Let us come to an understanding of what the gods are. What have men symbolized in them? The subject is both profound and complex. The gods, we might say, are the higher meaning that things acquire when looked at in connection with one another. Thus, Mars signifies the best in war: gallantry, fortitude and strength. Venus, the best in sexuality: the desirable, the beautiful, the sweet and gentle, the eternally feminine. Bacchus, the most exuberant: impetuosity, love of the countryside and of animals, the profound brotherhood of all living things, the joy that fantasy offers to wretched humanity. The gods are the best in our own selves, which, once that best has been isolated from the vulgar and base, assumes a personal aspect.

To say that there are no gods is to say things do not have, besides their material constitution, the aura of an idealized significance. It is to say that life has no meaning, that things lack connection. Each in his own manner, Titian and Poussin, are men of religious temperament, feeling what Goethe felt, devotion to nature. Velazquez is a complete atheist, a great infidel. With his brush, he sends the gods flying. Not only, in his bacchanal, is there no Bacchus – there is a shameless rascal standing in his place.

He is our painter. He has prepared the way for our era, freed from the gods; the administrative era in which, in place of Dionysus, we speak of alcoholism.

On Realism in Painting
1912

Some of the painters who sent their pictures to this year's Official Exhibition* have tried to introduce a little art within the frames. They have attempted to introduce forms, aesthetic structures. Herein lies the difference between the showcase or shop window and the picture-frame: through the former are seen things subject to universal gravitation; within the latter are seen forms liberated from existence.

And, with exemplary dexterity, the critics, the judges and the public have abused these young painters for their folly in creating a world of feeling, and for having allowed themselves to be moved by *un desiderio vano della bellezza antica* (a vain yearning for classical perfection).

And, as in the case of everything in Spain that aspires from darkness towards the light, they have been admonished by the evocation of what is called race, class, or national tradition. And it has been decided that we Spaniards have been realists – a decree of some gravity – and what is even worse, that we Spaniards have to be realists, of necessity. And then those painters have been called idealists; which apparently signifies some heinous condition, for the word is used as a patent insult.

And, finally, the works presented do not cause as much irritation as their 'tendencies'. Tendencies were what the Inquisition used to condemn. Tendency is the evil in the world. For tendency is the impulse away from the present towards what does not yet exist upon earth, towards what as yet does not exist except in the mind of a few. Tendencies always reach out towards ideas, from the real towards the ideal. One cannot tend towards reality, because that is where we are. To possess tendencies is to have ideas, to carry within oneself an ideal, like a sword in the belt or a lance in the hand. And this is forbidden, for, as Goethe said: 'All the ideal is of use for revolutionary ends.'

There is a ruling aesthetic principle which calls itself 'realism'. It is a very convenient principle. There is no need to invent anything. There are the objects; here are the canvas, palette and brushes. It is a matter of transferring the things there to the canvas here.

Can one help being astounded that people of some standing find Velazquez realistic or naturalistic? By so doing, they suppress with a delightful inconsequence all Velazquez' special virtues. Because if things themselves or nature had been what mattered most to Velazquez, he would have been nothing more than a disciple of the Flemish school

* The author refers to the annual Iberian Artists' Exhibition he had just visited.

or of the Italians of the Quattrocento. They are the conquerors of things and the nature of things.

The second half of the nineteenth century elevated Velazquez to the supreme summit of art. Not the Spaniards, be it noted: it was the English and the French who taught us to look at Velazquez. Delacroix taught us the secret of our two great painters: that their pictures are painted as jewellery is wrought, with precious materials, with unexpected and brilliant colours. Manet was the one who learnt this lesson and realized its potential. The Velazquez I am talking about is not the one seen by the lack-lustre eyes of Philip IV, but the Velazquez of Manet, Velazquez the Impressionist.

In fact there is nothing more opposed to realism than Impressionism. For the latter, there are no things, no solid bodies, and space is not a cubic boundary. The world is a surface of luminous values. Things, which begin here and end there, are fused in a marvellous furnace and start flowing interporously into each other. Who is capable of defining an object in a painting of Velazquez in his last period? Who is capable of indicating where, in *Las Meninas*, a hand begins and where it ends? One might aspire to hold some day the languid, ivory body of the Mona Lisa in one's arms, but that lady-in-waiting who hands the goblet to the little princess is fugitive as a shadow, and if we tried to grasp her we should be left with nothing in our hands but an impression.

No greater antithesis can be imagined than that existing between the painters who seek nature, things themselves, and those who seek merely the impression of things. The naturalists – like the Italians of the fifteenth century, the Flemings and the Germans – unite an endless series of visual acts in their paintings. They have previously studied each object and every part of it, and assigned each figure its place in the foreground, middle distance or background, they have learnt anatomy and perspective. They approach the objects fully-armed, as if to carry off a golden fleece, and this in truth is what things are for them: sublime riches which they look at with covetous eyes. For they are truly sensual and lovers of the earth and the realities of the earth. Their eyes adjust themselves to each distance and each object; they labour mightily in its pursuit. Reality reigns over the painter like the beloved mistress at the moment of paroxysm.

But as for our Velazquez . . . Contemplate in his self-portraits the disdain with which his weary eyes regard the world. Indifference, like a domestic muse, seems to loom up behind his shoulder. All that matters to him are the fleeting images his retina receives in the blink of an eyelid. And each painting of this genius is, rather than a fragment of the world, like an immense retina. Velazquez dazzles us with illusions, hallucinations. Far from compelling his eyes to adjust to the requirements of solid

bodies, he makes them accomodate to his vision, and, on filtering between his scarcely open lids, objects become first laminated, then pulverised into atoms of light. Light is what matters to Velazquez, not the solid bodies of things. Light, which is the material with which God created the world.

Of Goya there is no need to speak in this respect, for he is not merely indifferent to things, he is enraged by them. He draws near to them, it is true, but he does not have Velazquez' disdainful remoteness. On the contrary he approaches them with the violence of one possessed. In those pictures where he appears to have abandoned himself to the demoniacal furies which dwell in his heart like predatory birds, things are torn asunder or hacked to bits. Where can there be any place for realism in this genius of *caprichosidad*?

In Spain realism is one of so many vague words used to conceal the emptiness of exact ideas. It may well prove that, contrary to popular opinion, Spaniards have a closer affinity to the baroque and the dynamic, to distortions and expressiveness than was supposed. And this would be good news. Because the word realism usually denotes that dearth of invention, of love of form, of poetry and emotional reverberations, which parches the greater part of Spanish paintings. Realism then is prose. Realism then is the negation of art.

The painters who have been most discussed this year [1912], and whom I am not attempting to defend in particular, aspire to drive out the merchants in the temple, the prose of art. They are seeking, behind outward appearances, new forms to construct. Art is not a copy of things, but the creation of forms. Forty years of Impressionism are I think more than enough in which to gather new instruments of pictorial technique and enhance its possibilities. For the hundredth time, the pressing task of art is once again the conquest of form.

On the Artist's Viewpoint
1924

In the museum the corpse of an evolution is preserved under varnish. There it is, the outpouring of creativity that has flowed from man century after century. To preserve this evolution it has had to be taken apart and converted anew into fragments and frozen as in a refrigerator. Yet it is not difficult to bring the corpse to life again. It would be enough to arrange the pictures in a certain order and let one's gaze sweep rapidly over them. Then it would become evident that the progress of painting, from Giotto to our own day, is a single and simple gesture, with its beginning and its end. It is surprising that so simple a law has governed the variations of the visual arts in the Western world. And the most curious and disturbing thing about it is the analogy between this law and that which has governed the destinies of European philosophy. This parallelism between the two most distant fields of culture allows one to suspect the existence of a general principle even more extensive, which has operated upon the entire evolution of the European spirit.

What is the motive behind the evolution of painting? Each painting is a snapshot in which the motive is shown arrested. One is not looking for anything very complicated. What varies, what shifts itself in the painting and produces this diversity of styles is simply the painter's point of view.

It is natural that this should be so. The abstract idea is ubiquitous. The isosceles triangle presents the same aspect, whether on Earth or on Sirius. On the other hand, every visual image draws along the indelible mark of its own locality: that is, the image presents something seen from a definite point of view. This localization of what is seen may be strict or vague, but it cannot fail to be there. The spire of a church, the sail of a ship, present themselves at a distance we evaluate with experienced accuracy, the moon or the blue face of the sky appear in a remoteness that is necessarily imprecise, but very characteristic in its imprecision. We cannot say they are situated at a distance of so many miles; their localization and distance are vague, but this vagueness does not signify indetermination.

However, it is not the geodetic *quantity* of distance that is of decisive influence in the painter's viewpoint, but the optical *quality* of that distance. Near and far, which metrically are relative attributes, can have an absolute value for the eyes. In effect, the *near sight* and *long sight* spoken of in physiology are not notions which depend principally on

metrical factors, but are rather two distinct modes of looking.

Now, in the course of European artistic history, the view point of the painter has been progressively changing from near sight to long sight, and correspondingly painting, which begins with Giotto in being the painting of mass, has turned into the painting of void.

This means that the attention of the painter follows an itinerary of displacement in no way capricious. First he fixed his attention on the body or volume of the object, afterwards on what there was between the object and the eye, that is, on the void. And as this interval of space is found in front of the objects, it follows that the itinerary of the painter's gaze is a retrocession from the distant – even if it be relatively near – towards what is immediate to the eye.

According to this, the evolution of Western painting would consist in a retreat from the object towards the subject, the painter.

The reader can confirm this law governing the movement of pictorial art by chronologically reviewing the history of painting. In what follows I shall limit myself to some examples which could be called stages in the general itinerary.

The Quattrocento

The Flemish and Italian schools frenetically cultivated the painting of mass. One might say they painted with their hands. Each object appears with unequivocal solidity, corporeal, tangible. Covering it is a glossy skin, without pores or haziness, which seems to delight in proclaiming its rotund volume. There is no difference in the mode of treating things in the foreground and the background. The artist is content with representing distant objects as smaller than those nearby, but he paints both in the same manner. The distinction of planes is therefore merely abstract and is obtained by purely linear perspective. Pictorially, everything in these pictures is in the foreground – that is, everything is painted in close-up. The most diminutive figure in the far distance, is as complete, rounded and detached as the principle ones. It seems as if the painter had gone up to the distant place where it stood and painted it from close at hand.

But it is impossible to see closely various objects at the same time. Each fresh look has to keep shifting from one to the other in order to make each, successively, the centre of vision. This means that the focal point in the primitive picture is not a single one, but as many as there are objects in it. The picture is not painted in unity but in plurality. No part of it relates to any other; each part is perfect and apart. Hence we find that the clearest indication of whether a picture belongs to one or the other tendency – a painting of mass or a painting of space – would be to take a

fragment and see if, in isolation, it is sufficient to be the complete representation of something. In a canvas of Velazquez, by contrast, each fragment contains only vague, weird forms.

The primitive picture is, in a certain sense, the addition of many small pictures, each of which is independent and painted from a close viewpoint. The painter has directed an exclusive and analytical gaze at each one of the objects. Hence comes the fascinating richness of these fifteenth-century panels. We can never run out of things to see in them. We are always discovering some new little interior picture which we had failed to notice. On the other hand, they exclude contemplation as a whole. Our eyes have to wander step by step over the painted surface, lingering at the same viewpoints which the painter himself had taken.

The Renaissance

Near sight is exclusive, since it takes each object on its own and separates it from the rest. Raphael does not modify this point of view, but he introduces into the pictures an abstract element which provides it with a certain unity: composition or architecture. He continues painting object by object in the same way as a primitive and looks at things according to the same principle. But in place of ingenuously limiting himself, like the primitive painter, to painting what he sees as he sees it, he subjects everything to an alien power: the geometric idea of unity. Upon the analytical forms of the objects there falls, imperatively, the synthetic form of the composition, which is not the visible form of an object but a purely rational schema. (We find the same in Leonardo, for example, in his triangular pictures.)

Raphael's paintings, then, do not derive from a unified field of vision, nor can they be viewed from one. But there already exists in them the rational basis for unity.

Transition

If we pass from the primitives and the Renaissance towards Velazquez, we shall find in the Venetians, and above all in Tintoretto and El Greco, an intermediate stage. How should this be defined?

In Tintoretto and El Greco, two periods meet. Hence the uneasiness, the restlessness which agitates the work of both. The last representatives of the painting of mass, they are already aware of the future problem of the painting of space, without exactly getting to grips with it.

From its initiation, Venetian art tends towards a distant vision of

things. In Giorgione and Titian, substances would like to shed their compact solidity and float like clouds or diaphanous scarves, their shapes melting. However, the resolution to abandon the near and analytical viewpoint is lacking. For a hundred years the two principles contend, without a definitive victory for either. Tintoretto is an extreme example of this inner conflict, in which the distant vision almost wins the day. In the Escorial pictures he constructs great empty spaces. But for such an undertaking he has to lean on architectonic perspectives as on crutches. Without those colonnades and cornices receding into the background, Tintoretto's brush would fall into the abyss of the void he wanted to create.

El Greco signifies something of a regression. I think his modernity and his proximity to Velazquez have been exaggerated. With El Greco, volume continues to be of prime importance. Whereas Velazquez, in *Las Meninas* and *The Spinners*, piles up his figures to left and right, leaving more or less free the central space – as if this were the true protagonist – El Greco heaps over all the canvas corporeal masses that completely displace the air. His pictures are wont to be crammed full of flesh.

Nevertheless, canvases such as *The Resurrection, The Crucifixion* and *The Pentecost* tackle the treatment of depth with unusual energy. It is a mistake, however, to confuse the painting of depth with that of space or empty concavity. The former is nothing but a more skilful manner of dealing with volume. The latter, on the other hand, is a total inversion of pictorial intention.

What does happen in El Greco is that the architectonic principle completely takes possession of the objects represented, forcing them into an idealized pattern. In this manner the analytical vision, which seeks volume by emphasizing each figure, becomes mediated and as it were neutralized by the synthetizing intention. The system of formal dynamism which reigns over the picture imposes a unity upon it and fosters the illusion of a single viewpoint.

The Chiaroscurists

The composition of Raphael, the dynamic scheme of El Greco, such are the bases of unity which the artist casts upon his picture, but nothing more. Each thing in the canvas continues to affirm its volume, and, consequently, its independence and particularization. Those unifications are, therefore, of the same abstract lineage as the geometric perspective of the primitives. Derived from pure reason, they show themselves incapable of informing the material of the picture as a whole; in other

27

words, they are not pictorial principles. Each portion of the work is painted without their mediation.

In contrast to these notions, chiaroscuro signifies a more radical innovation.

While the painter's eye looks for the body of things, the objects which inhabit the painted area demand, each for itself, an exclusive and privileged point of view. The picture will possess a feudal constitution in which each element will maintain its personal rights. But now there steals among them a new force endowed with a magic power which is allowed – indeed obliged – to be ubiquitous, occupying all the canvas with no need to dispossess the other elements. This magic force is light. Here we have a principle of unity which is not abstract but real, one thing among many things and not an idea or plan. The unity of illumination or chiaroscuro imposes a unique point of view. The painter must now see the whole of his picture as being immersed in this all-embracing quality of light.

The painters concerned are Ribera, Caravaggio, and the young Velazquez (*Adoration of the Magi*). They still seek out corporeality in a traditional way, but already this has ceased to be their primary concern. The object in itself begins to be disregarded and to have no other role but to serve as support and background to the light shed upon it. These painters follow the light in its course, dwelling on it as it glides over the surface of solid masses.

You observe the shift of viewpoint this implies? The Velazquez of the *Adoration of the Magi* is not paying heed to the picture as such, but to its *surface*, where the light strikes and is reflected. Thus there has been a withdrawal of the gaze, which ceases to behave like a hand and looses its grip on the rounded solid. Now the glance rests where substance begins and light falls resplendent; from thence it moves to another spot on another object where a similar light shimmers intensely. The painter has achieved a magic solidarity and unification of all the light areas in contrast to the dark elements. Things previously most unequal in their form and condition now become balanced. The primacy of objects comes to an end. Already they are ceasing to be of interest in themselves and are beginning to be no more than a pretext for something else.

Velazquez

Thanks to chiaroscuro, the unity of the picture becomes intrinsic not merely obtained by extrinsic means. However, beneath the light, the volumes continue to exist. The painting of mass persists behind the refulgent veil of light.

28

In order to overcome this dualism the intervention of some disdainful genius was necessary, one who was determined to have no concern for body, to deny its pretension to solidity. This disdainful genius was Velazquez.

The primitive, enamoured of the objective body, eagerly seeks it out with his tactile glance, passionately embraces it. The chiaroscurist, already less concerned with shapes, lets his glance wander, along the ray of light which flits from object to object. Velazquez, with formidable audacity, performs the great act of disdain required to originate a completely new style of painting: he arrests his glance. Nothing more. The great revolution consists in this act.

Up to then the painter's eye had moved, in Ptolemaic fashion, in servile orbit around each object. Velazquez despotically resolves to fix the point of view. The entire picture will be born of a single act of vision, and objects must make what effort they can to be included in the visual ray. It is therefore a Copernican revolution, comparable to that advanced by Descartes, Hume and Kant in philosophy. The artist's eye establishes itself in the centre of the plastic cosmos and around it wander the shapes of objects. The rigid gaze shoots straight ahead, without deviating, without preference for any single object. When it meets with an object, the glance pays no special attention to it; thus, the thing becomes converted, not into a rounded body, but into a mere surface which intercepts the vision.

The point of view has retreated, it has withdrawn from the object, and from near sight we have passed to long sight, which, in this context, is even nearer than the former. Between solid forms and the eye floats that more immediate substance: space, the air. Converted into pure reflections, objects have lost their solidity and their contours. The painter has thrown back his head and between half-closed lids has reduced the particular form of each object to molecules of light, to pure sparks of colour. In return, his picture can be looked at from a single point of view, in totality and all at once.

Near sight dissociates, analyses, distinguishes – it is feudal. Long sight synthetises, fuses, jumbles – it is democratic. The point of view becomes summary. The painting of mass has become definitively converted into the painting of space.

Impressionism

Needless to say, the moderate principles of the Renaissance still lingered on in Velazquez. The new style does not appear in all its radicalism until the Impressionists and neo-Impressionists.

29

The premises formulated at the beginning of this essay seemed to imply that, having arrived at the painting of space, the evolution would be complete. The point of view, having turned from the multiple and near into the unique and distant, seems to have exhausted its possible itinerary. But this is not so. Presently we shall see that it is capable of retreating still further towards the subject. From 1870 up to the present day the displacement has continued, and these latest stages, precisely by their improbable and paradoxical character, confirm the implacable law I suggested at the beginning. The artist, who withdraws from the world around him, ends by retiring into his own self.

I said that Velazquez' gaze, when it met with an object, converted it into surface. But, while making its journey, the eye's glance has taken pleasure in piercing the air which floats between the cornea and distant objects. In *Las Meninas* and *The Spinners* we notice the enjoyment with which the artist has accentuated empty space as such. Velazquez looks directly into the background, hence he encounters an enormous mass of air between him and the limit of his visual field. Now, to see something with the central ray of the eye is what is called *direct* vision. But around this axial ray the pupil sends out many other rays which see in an *oblique* manner. The impression of concavity arises from the direct gaze. If we eliminate this there remains only the oblique viewpoint, the side-glance from 'the corner of the eye' which is the summit of disdain. Then the hollow disappears, and the field of vision tends to convert itself entirely into one surface.

This is what the successive schools of Impressionism have done, drawing the background of the Velazquian hollow into a foreground, which for lack of comparison then ceases to exist. The painting tends to become flat, as is the canvas on which it is made. It therefore achieves the elimination of all tactile and corporeal resonance. Moreover, the oblique viewpoint atomizes objects almost beyond recognition. Instead of painting objects as they are seen, the act of seeing is itself painted; an impression is painted, that is, a multitude of sensations. With this, art has withdrawn completely from the world and begins to attend to the activity of the subject. Sensations are no longer in any sense things but are subjective states through which and by means of which things appear to us.

You notice the change this signifies in the point of view? It would seem that in seeking the object nearest the cornea, the viewpoint had arrived as close as possible to the subject and as far as possible from the objects. Not so! The point of view continues its inexorable course of retreat. Not halting at the cornea, it audaciously crosses the greatest frontier and penetrates into vision itself, into the subject proper.

Cézanne, in the midst of his Impressionist tradition, discovers volume. Cubes, cylinders and cones begin to appear on the canvas. Bewildered, one might have thought that the pictorial peregrination had come full circle and we were about to relapse into the point of view of Giotto. A further mistake! In the history of art there have always been lateral tendencies which gravitate towards archaism. Nevertheless, the central current of evolution rushes over these in full flood and follows its inevitable course.

The Cubism of Cézanne and of those who were actually Cubist, is but one more step towards painting's inward penetration. Sensations, the theme of Impressionism, are subjective states; for that reason, they are realities, effective modifications of the subject. But still further within the subject are found ideas. For ideas, too, are realities which happen in the soul of the individual, but differ from sensations in that their content – what is conceived – is unreal and on occasion utterly impossible. When I think of a strictly geometric cylinder, my *thought* is an effective act which is produced in me; on the other hand, the geometric cylinder *of which* I think is an unreal object. Ideas, therefore, are subjective realities which contain virtual objects, a whole world of our making, distinct from that which the eyes transmit to us, emerging from the innermost recesses of the psyche.

Very well: the volumes Cézanne evokes have nothing to do with those that Giotto discovers; they are rather their antagonists. Giotto seeks the volume proper to each thing, its most real and tangible corporeality. Prior to him only the two-dimensional Byzantine image was known. Cézanne, on the contrary, endows the bodies of things with unreal volumes of pure invention, which have only a metaphorical connection with them. From him onwards painting paints only ideas – which, indeed, are also objects, but ideal objects, immanent to the subject or intra-subjective.

The ambiguity of Cubism is nothing else but a particular manner within contemporary Expressionism. In the impression, exterior objectivity has reached its minimum. And then a new displacement of the viewpoint was possible only if, leaping behind the retina – subtle frontier between the external and the internal – painting completely inverted its function and, instead of introducing us to what is outside, endeavoured to pour out on the canvas what is inside: invented, idealized objects. Note how by a simple advance of the point of view along the same and only path it has followed from the start, an inverse result is reached. The eyes, instead of absorbing things, convert themselves into projectors of inner landscapes and creations of the mind. Before, they drained the

real world: now, they are outlets of unreality.

Possibly the art of today has little aesthetic value, but anyone who sees in it nothing but a caprice can be sure he has understood neither the new art nor the old. Inexorably, evolution brought painting – and art in general – to what it is today.

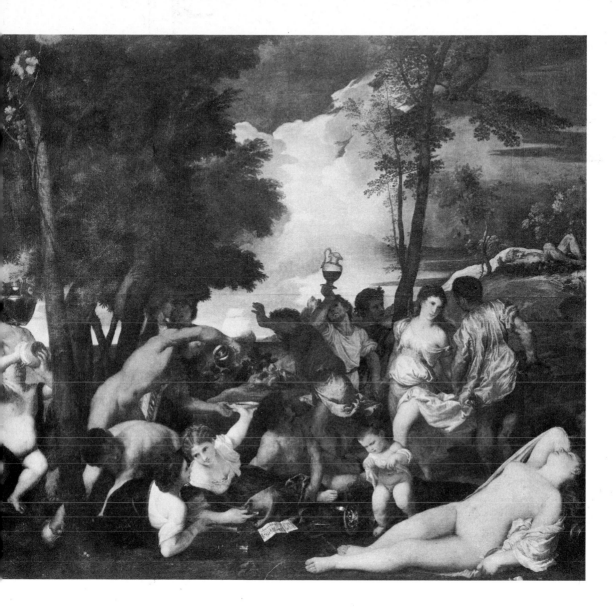

1 Titian *Bacchanal, c.*1518, Museo del Prado, Madrid
'I do not believe there is a picture in the world as optimistic as this one. . . . Men and women have chosen this peaceful corner of the universe to enjoy existence: they drink, laugh, talk, dance, caress one another and sleep. . . . This picture might have been given a more expressive name; it could have been called what in truth it is: the triumph of the moment.' ('Three Bacchanalian Pictures', p. 15)

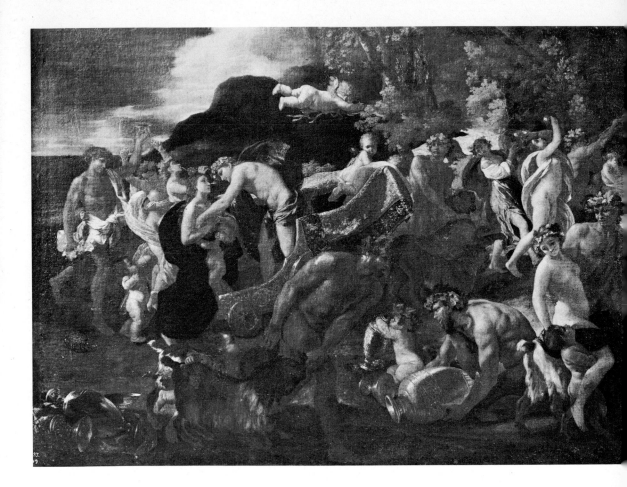

2 Poussin *Bacchanal*, *c*.1632–6, Museo del Prado, Madrid
'The figures in Poussin's picture are not men, they are gods ... The realistic
element – human and only human – of Titian is missing here. ... Poussin is
painting at a time when the Renaissance itself has passed by like a human bacchanal.
He is living in the morning after the Titianesque orgy, he weeps from weariness
and disillusionment.' ('Three Bacchanalian Pictures', p. 18)

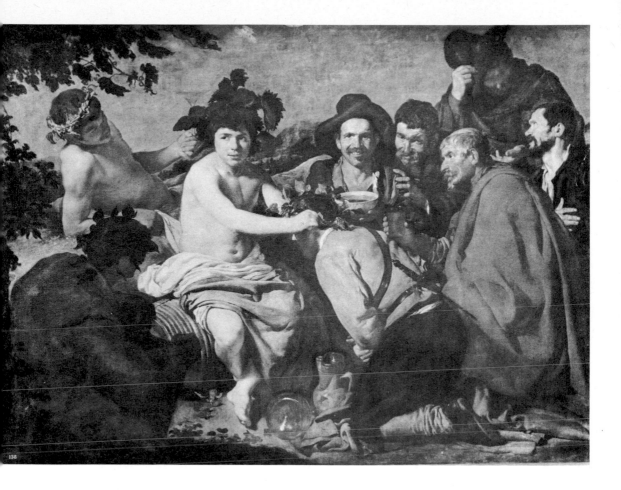

3 Velazquez *The Drinkers*, *c.* 1626–8, Museo del Prado, Madrid
 'Velazquez . . . gets together a few rough labourers He is our painter. He
 has prepared the way for our era, freed from the gods.' ('Three Bacchanalian
 Pictures', p. 19)

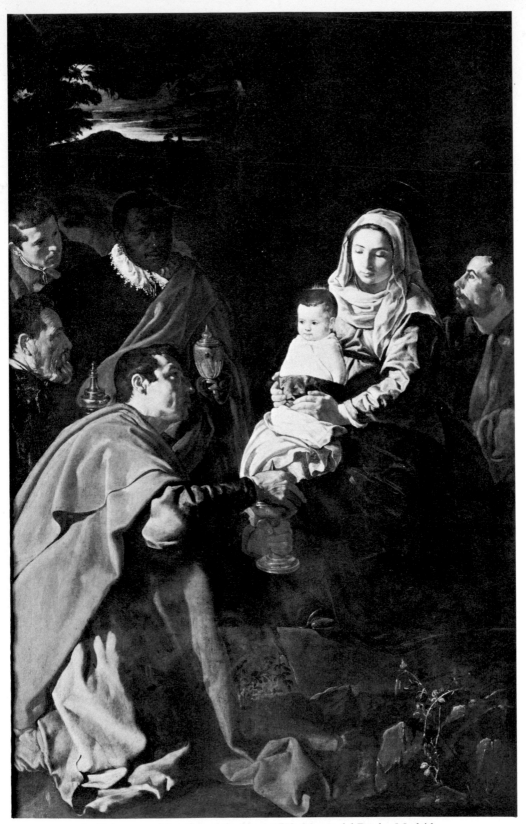

4 Velazquez *Adoration of the Magi*, 1619, Museo del Prado, Madrid
Painted by the young Velazquez in Seville soon after he had become a master
painter. 'The Velazquez of the *Adoration of the Magi* is not paying heed to the
picture as such, but to its *surface*, where the light strikes and is reflected.' ('On
the Artist's Viewpoint', p. 28)

5 Velazquez, detail from *Las Meninas* (see plate 20) showing the Infanta
'Who is capable of defining an object in a painting of Velazquez in his last period?
Who is capable of indicating where, in *Las Meninas*, a hand begins and where it
ends?' ('On Realism in Painting', p. 22)

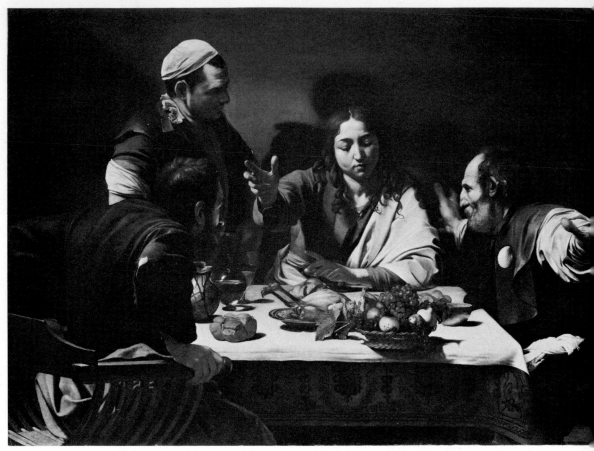

6 Caravaggio *The Supper at Emmaus* 1596–8, National Gallery, London
Caravaggio's revolutionary use of light was employed by Velazquez in his early
bodegones, but Velazquez' work does not have the violence inherent in Caravaggio's
paintings. (see 'Introduction to Velazquez', p. 97)

7 Rubens *Christ on the Cross, c.*1618, Musée Royal des Beaux-Arts, Antwerp
Velazquez got to know this great master of Baroque painting in Madrid, in 1628,
but the two painters were very different in temperament and in their approach to
their painting. (see 'Introduction to Velazquez', p. 86)

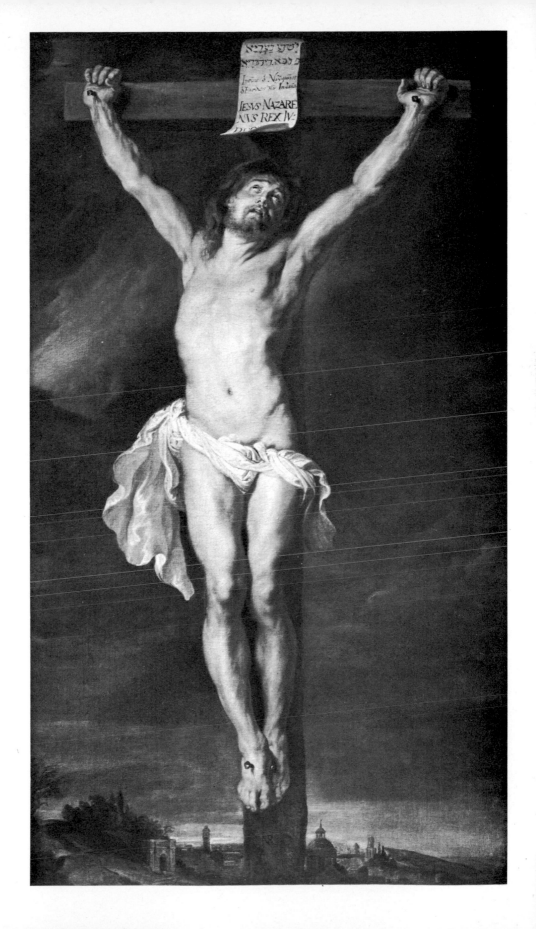

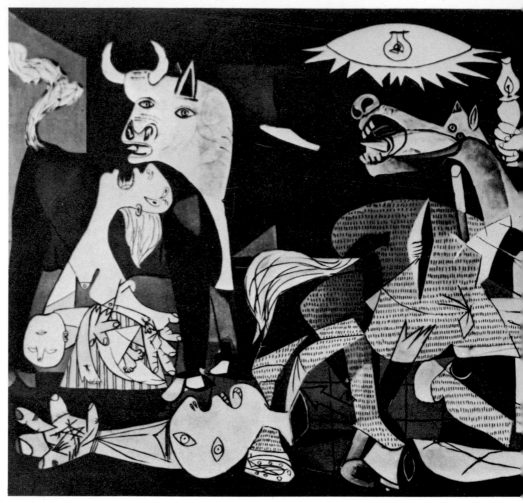

8 Picasso *Guernica* 1937, Museum of Modern Art, New York

9 Paul Klee *Comedy* 1921, Tate Gallery, London

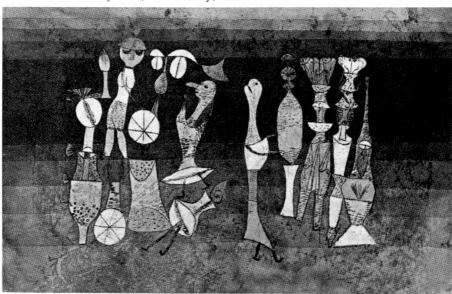

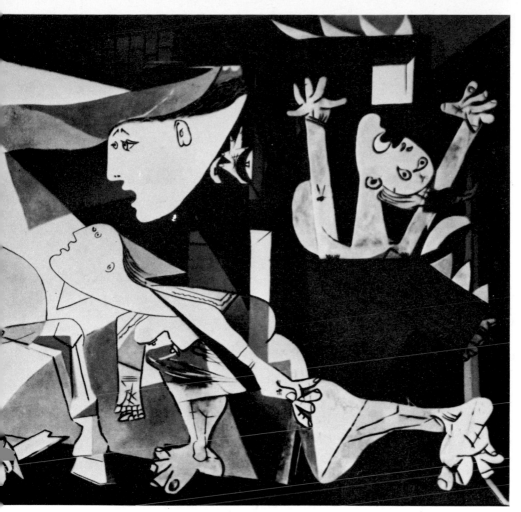

'The (modern) painter, far from stumbling towards reality, is seen to be proceeding in the contrary direction. He has set himself resolutely to distort reality, break its human image, dehumanize it.' ('The Dehumanization of Art', p. 71)

10 Jackson Pollock *Painting* 1952, Tate Gallery, London

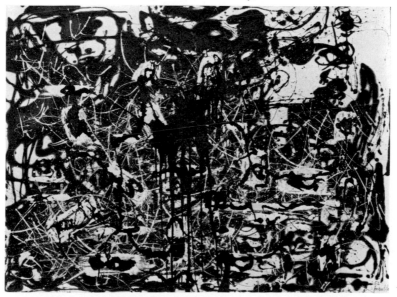

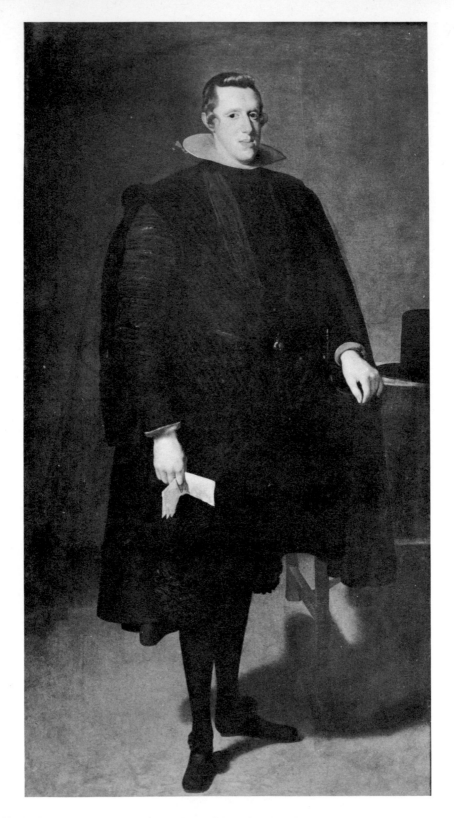

11 Velazquez *Philip IV*, *c.* 1625, Museo del Prado, Madrid
One of Velazquez' first portraits of his royal patron and friend, painted soon
after Philip IV had chosen him as his painter. (see 'Introduction to Velazquez',
p. 86)

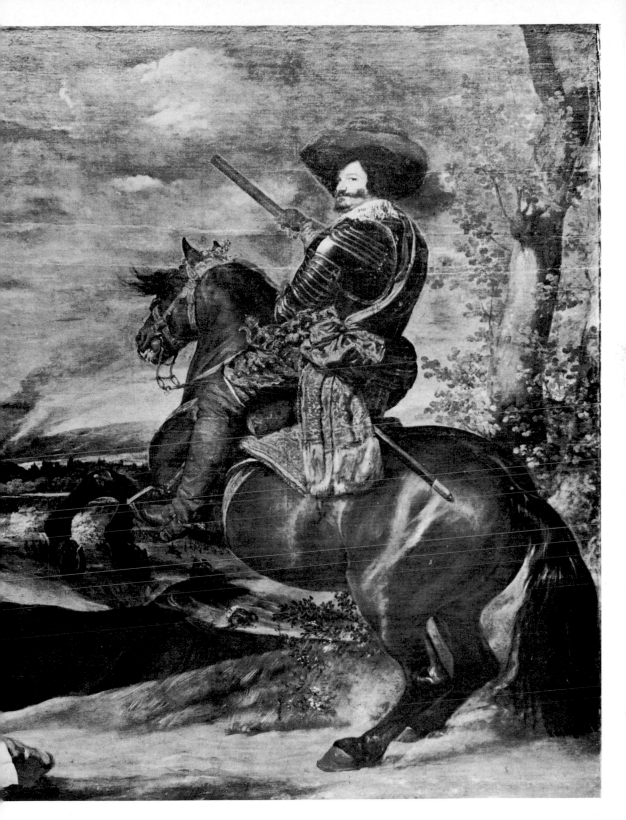

12 Velazquez *Count-Duke of Olivares*, *c.* 1635, Museo del Prado, Madrid
Philip IV's chief minister, who recommended the young Velazquez to the king.
(see 'Introduction to Velazquez', p. 86)

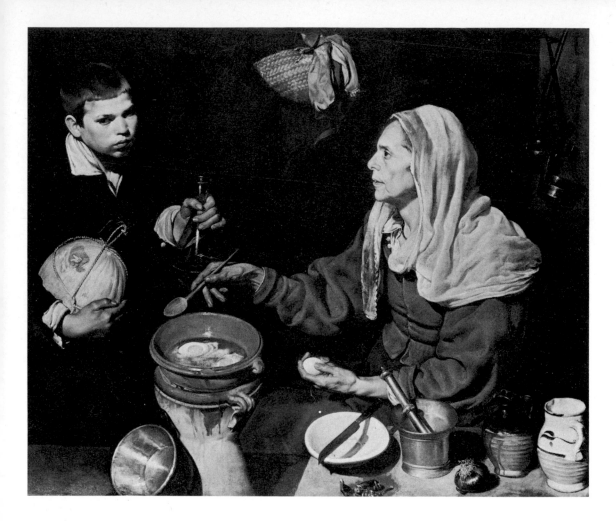

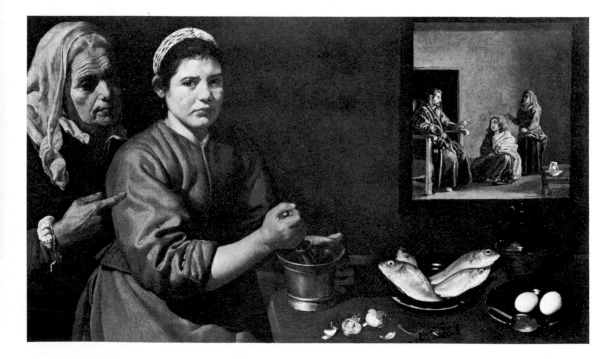

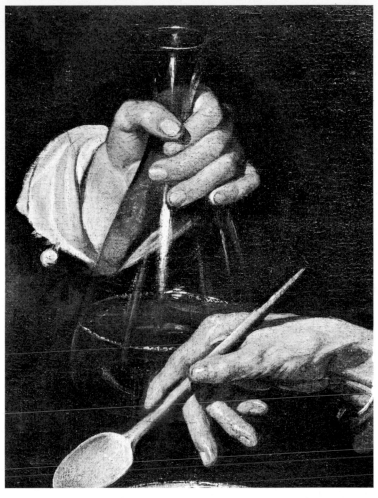

15 Velazquez, detail from *Old Woman Frying Eggs*. It is interesting to compare the hands in this early painting with the treatment of the Infanta's hand in *Las Meninas*, which is a late work. (see plate 5)

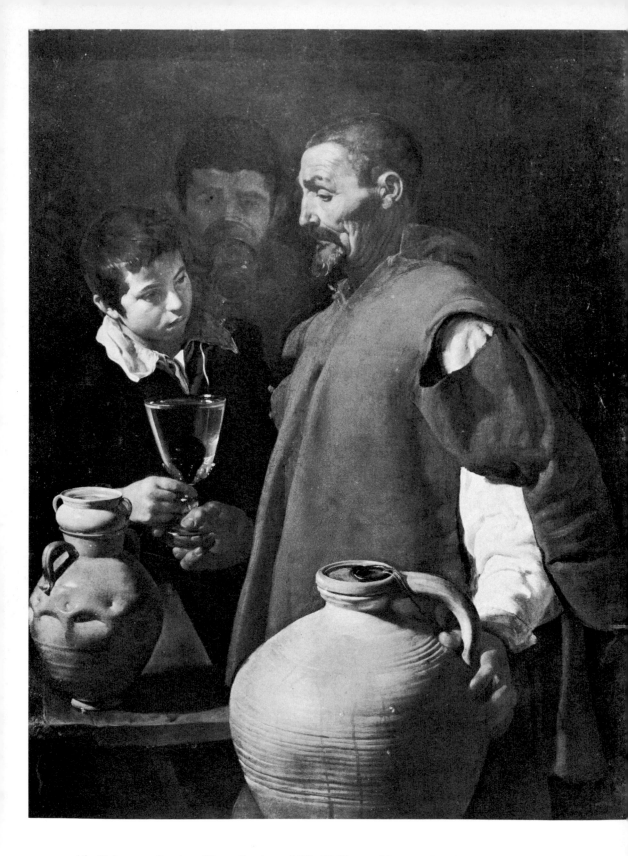

16 Velazquez *Corsican Water-Carrier*, *c.*1620, Wellington Museum, London
Velazquez' most famous *bodegon*, painted while he was still in Seville.

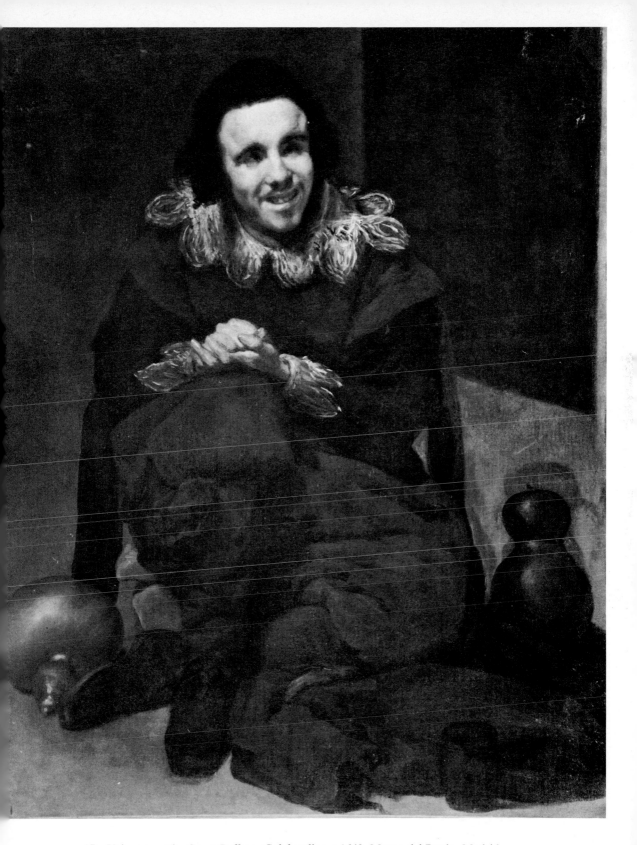

17 Velazquez *The Court Buffoon, Calabacillas, c.*1640, Museo del Prado, Madrid
One of a series of portraits of court jesters painted by Velazquez while he was
court painter.

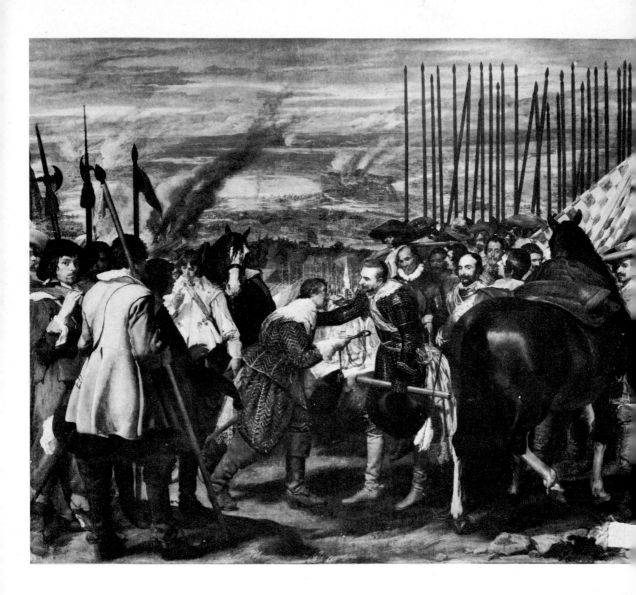

18 Velazquez *The Surrender of Breda* 1635, Museo del Prado, Madrid
'Nothing disquiets us in his canvases, despite the fact that in some there are
many figures, and in *The Surrender of Breda* a whole crowd of people, which at
the hand of any other painter would give an impression of tumult.' ('Introduction
to Velazquez', p. 104)

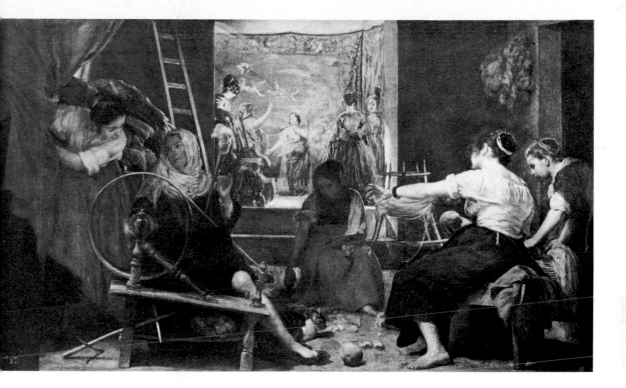

19 Velazquez *The Spinners (Pallas and Arachne)*, *c.*1644–8, Museo del Prado, Madrid
The painting has been reproduced without the eighteenth century extension. Ortega was the first to recognize the mythological subject-matter of the painting. (see Appendix, p. 135)

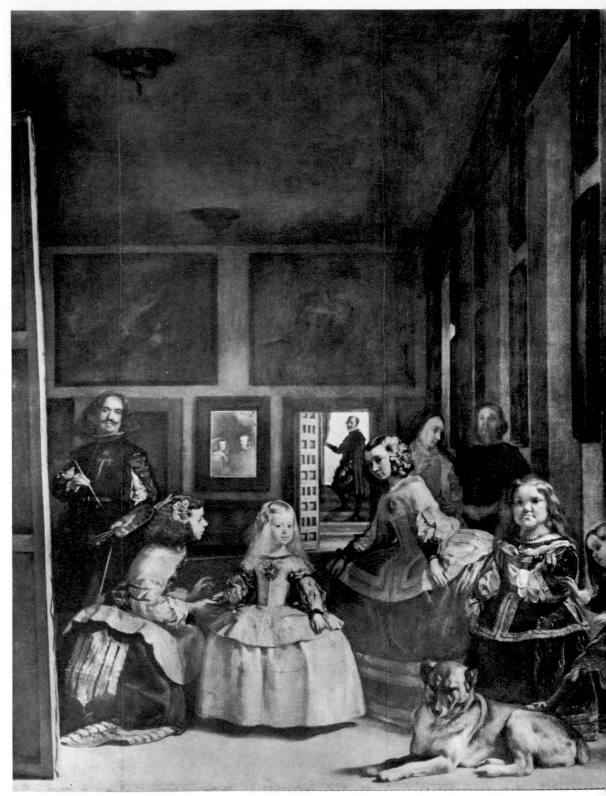

20 Velazquez *The Maids of Honour (Las Meninas)* 1656, Museo del Prado, Madrid
In this royal family portrait which was to be Velazquez' last great masterpiece,
the king and queen are reflected in the mirror behind the princess. For Ortega
Las Meninas illustrates the outstanding feature of Velazquez' paintings – his
way of painting movement by concentrating on 'one single, arrested moment'.
('Introduction to Velazquez', p. 105)

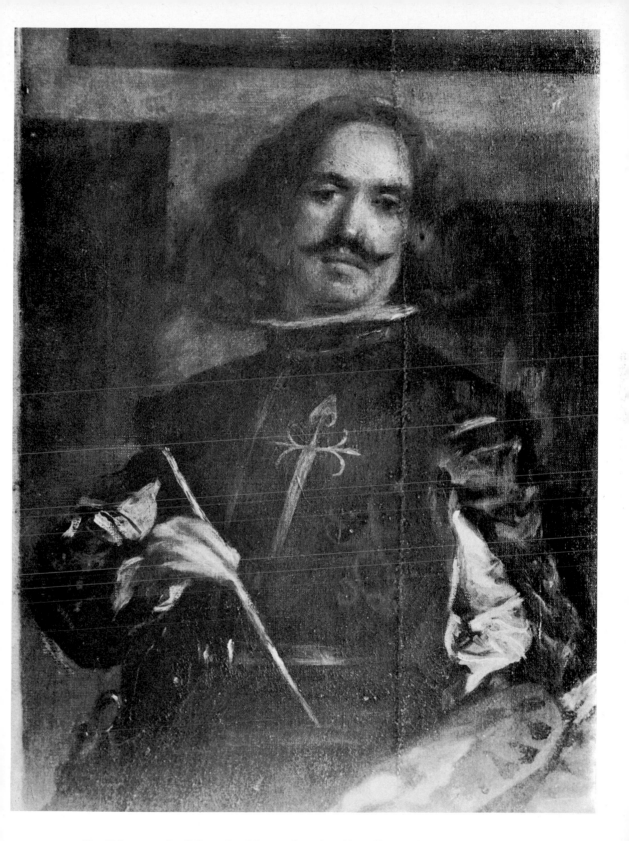

21 Velazquez, detail from *Las Meninas* (see plate 20): self portrait
Velazquez is wearing the Cross of Santiago, but this must have been added to
the painting later since he did not receive the order until 1658.

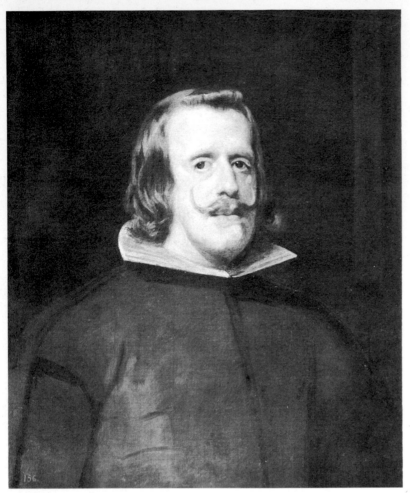

22 Velazquez *Philip IV Aged about Fifty*, *c.*1654, Museo del Prado, Madrid
A late portrait of Velazquez' royal patron.

23 Velazquez *Mercury and Argos* 1659, Museo del Prado, Madrid
Velazquez' last mythological painting, made to decorate the Royal Palace. 'For
Velazquez' contemporaries – painters and public – a mythological theme pro-
mised something out of this world. For Velazquez it is a motif which allows the
grouping of figures in an intelligible scene. But he does not accompany the myth
in its flight beyond this world.' ('Introduction to Velazquez', p. 102)

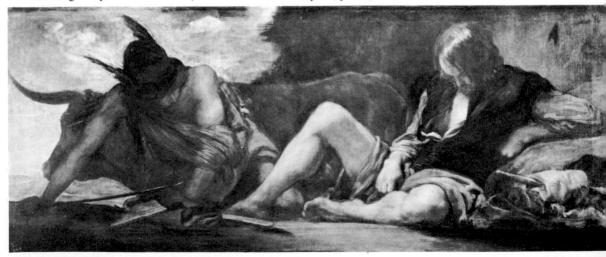

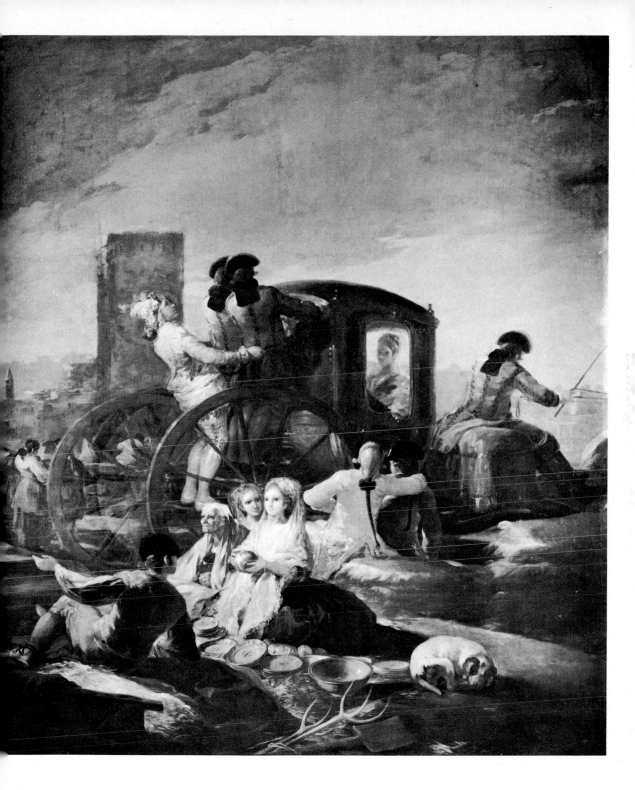

24 Goya *The Crockery-Seller* 1778, Museo del Prado, Madrid
One of Goya's early cartoons for tapestries, designed to decorate the Royal
Palace. (see 'Goya', p. 112)

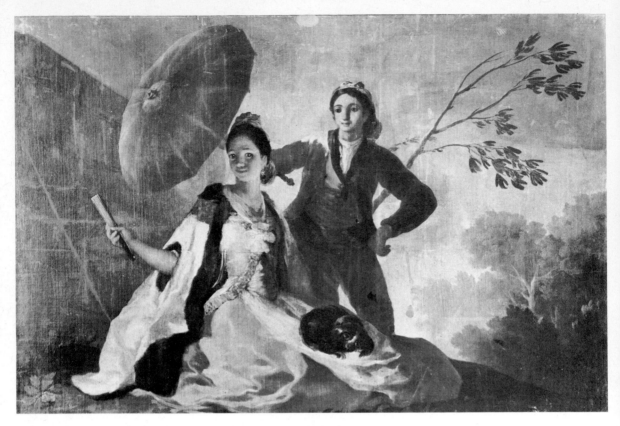

25 Goya *The Parasol* 1777, Museo del Prado, Madrid
Another of Goya's early cartoons for tapestries. Ortega thinks that Goya's use
of 'popular' themes in these early works was dictated by the vogue of 'popularism'
in eighteenth-century Spain. (see 'Goya', p. 112)

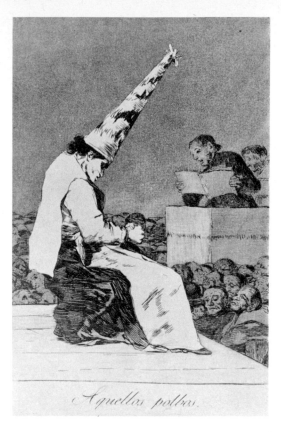

26 Goya a plate from the satirical series of
 etchings *Los Caprichos* 1797 (British
 Museum, London) representing a victim of
 the Inquisition. (see Introduction, p. 11)

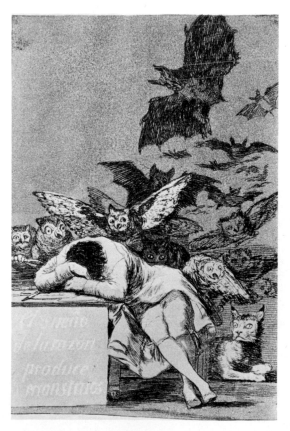

27 Goya *The Sleep of Reason Produces Mon-
 sters* 1797, Museo del Prado, Madrid
 This plate was originally designed to intro-
 duce *Los Caprichos*. The man asleep is Goya
 himself. (see Introduction, p. 11)

28 Goya *Family of Charles IV* 1800, Museo del Prado, Madrid
Goya shows himself at his easel, just as Velazquez did in *Las Meninas*. When
Goya became First Painter to the Chamber in 1799 he painted a series of royal
portraits. (see Introduction, p. 11)

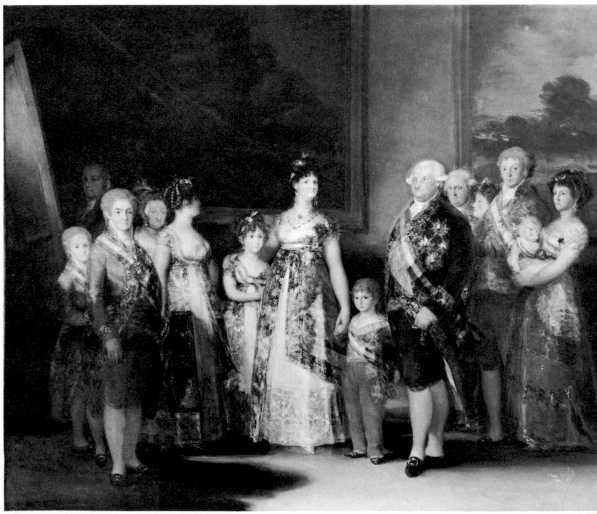

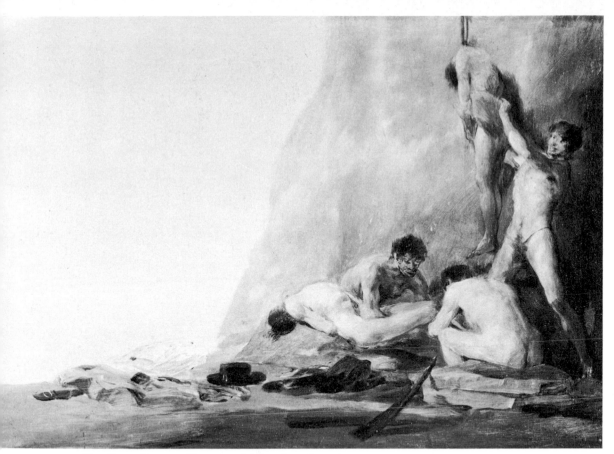

29 Goya *Savages Flaying and Disembowelling their Victim*, *c.*1810–12, Musée des
Beaux-Arts, Besançon
One of a series of scenes of savages painted by Goya during the Spanish War of
Independence. (see Introduction, p. 12)

30 Goya *The Clothed Maja*, *c.*1802–6, Museo del Prado, Madrid
One of a famous pair of paintings. *The Naked Maja* shows the same sitter in the
same pose. The sitter was almost certainly not the Duchess of Alba for the paintings
were made after her death in 1802. (see 'Goya', p. 120)

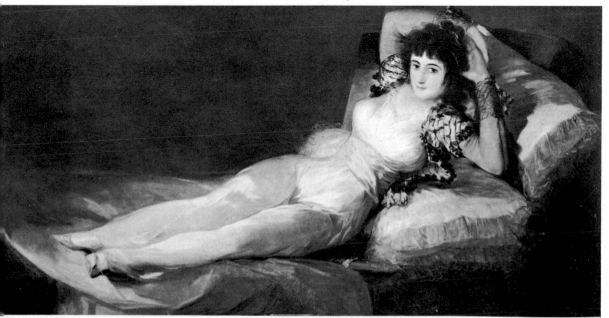

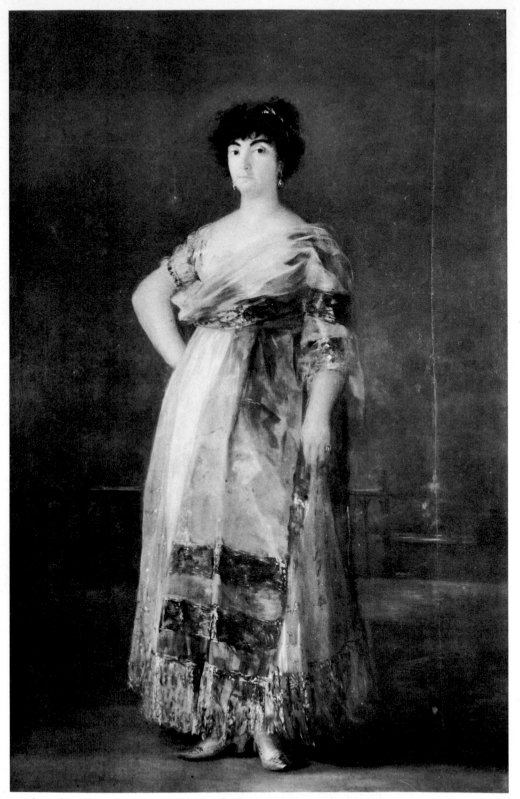

31 Goya *La Tirana* 1799, Academia de San Fernando, Madrid
This is the second portrait which Goya made of this actress, whom he had already
painted in 1794–5. The theatre and the bullfight were the two main 'popular'
themes. However Ortega maintains that it was only in his later works that Goya
painted 'popular' subjects from choice. (see 'Goya', p. 121)

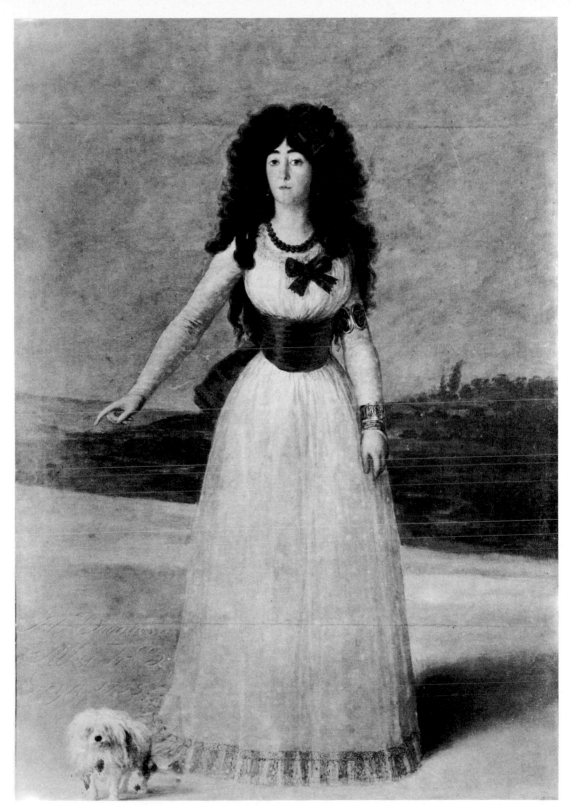

32 Goya *The Duchess of Alba* 1795, Alba Collection, Madrid
The Duchess of Alba was one of the most attractive women at the court. Goya's
short-lived infatuation with the Duchess, during his stay at her estate in 1796–7,
has been the cause of much speculation. (see 'Goya', p. 121)

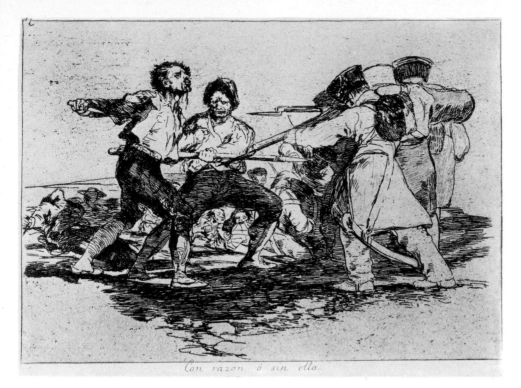

Con razon ó sin ella.

33 and 34 Goya two plates from *The Disasters of War*, the series of etchings relating
the events of the Spanish War of Independence. (see Introduction, p. 12)
33 plate 2, 1810
34 plate 30, *c.* 1812

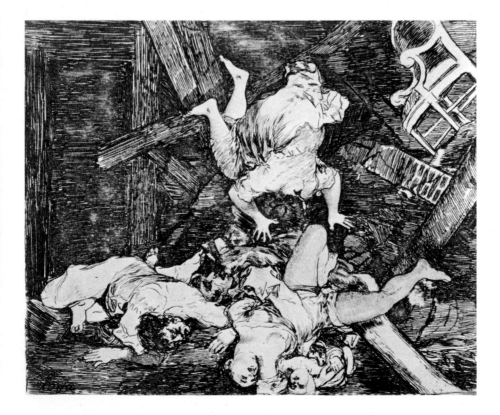

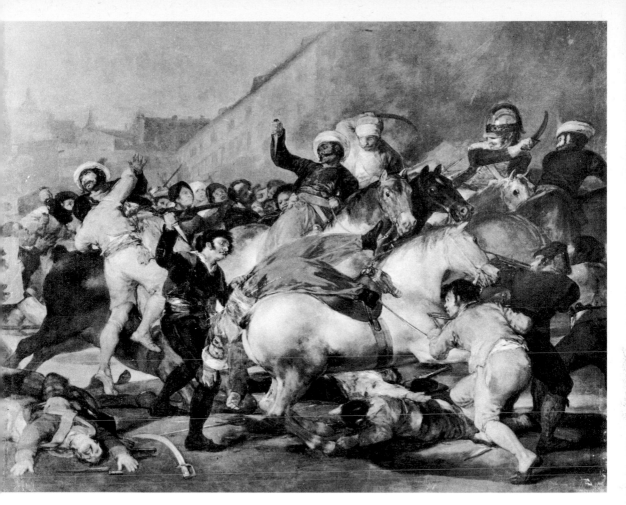

35 Goya *The Second of May* 1814, Museo del Prado, Madrid
The attack of 2 May 1808 by the Madrid populace on Napoleon's troops which
had occupied Madrid, one of the first incidents of the Spanish War of Independence.
(see Introduction, p. 12)

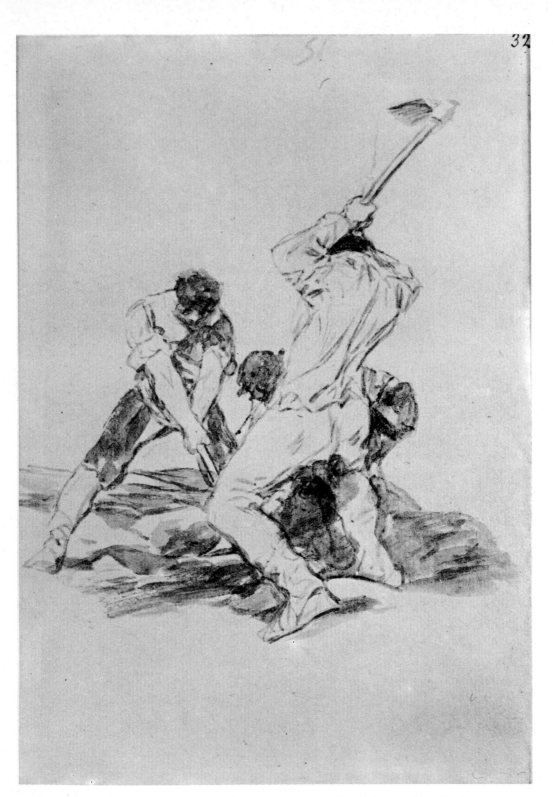

36 Goya *Men with Mattocks*, *c.*1810–15, Metropolitan Museum, New York
One of a series of wash drawings showing men at work, possibly made during
the Spanish War of Independence. They reflect the violence which is also expressed
in *The Disasters of War*.

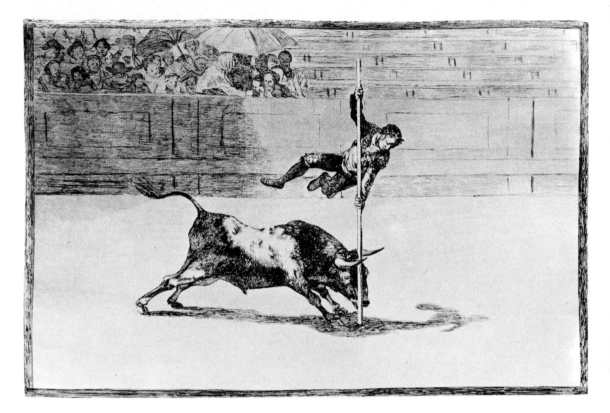

37 Goya plate 20 from the series of etchings *La Tauromaquia* 1815, British Museum,
London
Ortega shows how the bullfight emerged as an important 'popular' theme in the
second half of the eighteenth century. (see 'Goya', p. 114)

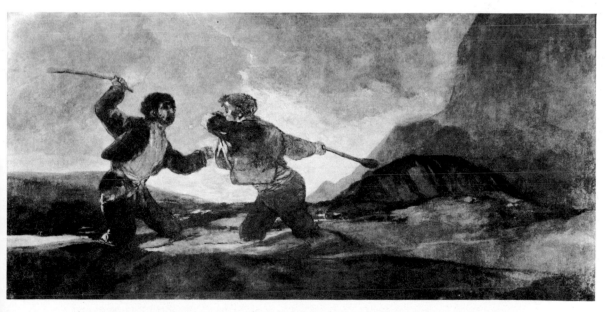

38 Goya *Duel with Clubs*. One of the series of 'Black Paintings' 1820–2, Museo del
Prado, Madrid, with which Goya decorated his country house near Madrid,
towards the end of his life. (see Introduction, p. 12)

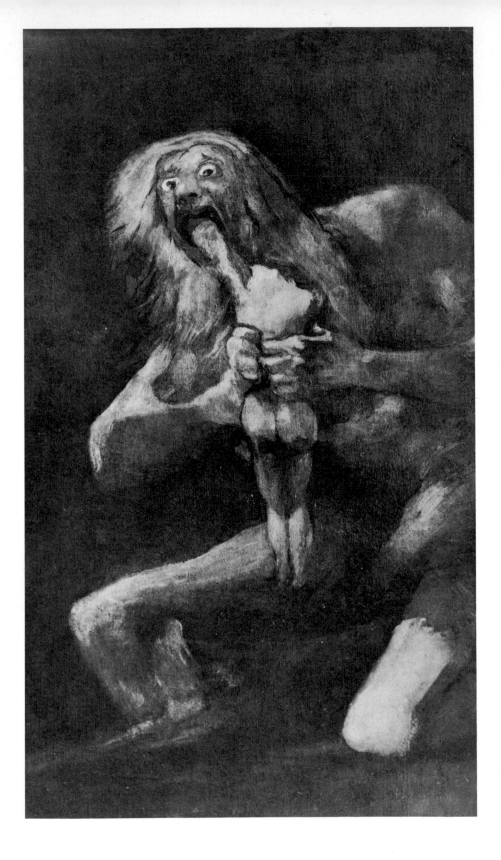

39 Goya *Saturn Devouring his Children*. One of the series of 'Black Paintings' 1820–2,
Museo del Prado, Madrid. (see Introduction, p. 12)

The Dehumanization of Art
1925

The study of art from the sociological point of view might at first seem a barren theme, rather like studying a man from his shadow. At first sight, the social effects of art are so extrinsic, so remote from aesthetic essentials, that it is not easy to see how from this viewpoint one can successfully explore the inner nature of style. But the fruitful aspects of a sociology of art were unexpectedly revealed to me when, a few years ago, I happened to be writing about the musical era which started with Debussy. My purpose was to define as clearly as possible the difference between modern and traditional music. The problem was strictly aesthetic, yet I found the shortest road towards its solution started from a simple sociological phenomenon: the unpopularity of modern music.

I should now like to consider all the arts which are still thriving in Europe: modern music, painting, poetry, and theatre. The unity that every era maintains within its different manifestations is indeed surprising and mysterious. An identical inspiration is recognizable in the most diverse arts. Without being aware of it, the young musician is attempting to realize in sound exactly the same aesthetic values as his contemporaries, the painter, the poet and the dramatist. And this identity of artistic aspiration must, necessarily, have an identical sociological effect. The unpopularity of today's music is equalled by the unpopularity of the other arts. All new art is unpopular, necessarily so, and not by chance or accident.

It will be said that every new style must go through a period of quarantine, and one may recall the conflicts that accompanied the advent of Romanticism. The unpopularity of modern art, however, is of a very distinct kind: we would do well to distinguish between what is not popular and what is unpopular. An innovatory style takes a certain time in winning popularity; it is not popular, but neither is it unpopular. The example of the public's acceptance of Romanticism was the exact opposite of that presented by modern art.

It made a very rapid conquest of the 'people', whose affection had never been deeply held by the old classical art. The enemy with which Romanticism had to contend was precisely that select minority who had remained loyal to the archaic structure of the poetic *ancien régime*. Romantic works were the first – since the invention of printing – to enjoy large editions. Above all other movements Romanticism was the most

popular. The first-born of democracy, it was treated by the masses with the greatest affection.

Modern art, on the other hand, has the masses against it, and this will always be so since it is unpopular in essence; even more, it is anti-popular. Any new work whatsoever automatically produces a curious sociological effect on the public, splitting it into two parts. One, the lesser group, is formed by a small number of persons who are favorable to it; the other, the great majority, is hostile. (Let us leave aside those equivocal creatures, the snobs.) Thus the work of art acts as a social force creating two antagonistic groups, separating the masses into two different castes of men.

What is the principle that differentiates these two classes? Every work of art awakens different responses: some people like it, others do not; some like it less, others more. No principle is involved: the accident of our individual disposition will decide where we stand. But in the case of modern art the separation occurs on a deeper plane than the mere differences in individual taste. It is not a matter of the majority of the public *not liking* the new work and the minority liking it. What happens is that the majority, the mass of the people, *does not understand* it.

In my opinion, the characteristic of contemporary art 'from the socio-logical point of view' is that it divides the public into these two classes of men: those who understand it and those who do not. This implies that the one group possesses an organ of comprehension denied to the other; that they are two distinct varieties of the human species. Modern art, evidently, is not for everybody, as was Romantic art, but from the out-set is aimed at a special, gifted minority. Hence the irritation it arouses in the majority. When someone does not like a work of art, but has under-stood it, he feels superior to it and has no room for irritation. But when distaste arises from the fact of its not having been understood, then the spectator feels humiliated, with an obscure awareness of his inferiority for which he must compensate by an indignant assertion of himself. Modern art, by its mere presence, obliges the good bourgeois to feel what he is: a good bourgeois, unfit for artistic sacraments, blind and deaf to all aesthetic beauty. Obviously this cannot happen with impunity after a hundred years of all-embracing flattery of the masses and the apotheosis of 'the people'. Accustomed to dominate in everything, the masses feel that their 'rights' are threatened by modern art, which is an art of privi-lege, of an aristocracy of instinct. Wherever the young muses make their appearance, the crowd boos.

For a century and a half 'the people' have pretended to be the whole of society. The music of Stravinsky or the drama of Pirandello obliges them to recognize themselves for what they are – one ingredient among many in the social structure, inert material of the historical process. On

the other hand, modern art also helps the élite to know and recognize each other amid the greyness of the crowd, and to learn their role which consists of being the few who have to struggle against the many.

The time is approaching when society, from politics to art, will once more organize itself into two orders: that of the distinguished and that of the vulgar. The undifferentiated unity – chaotic, amorphous, without an anatomical structure or governing discipline cannot continue. Beneath all contemporary life lies a profound and disturbing misconception: the assumption that real equality exists among men. While every step we take plainly shows us the contrary.

If the new art is not intelligible to everybody, this implies that its resources are not those generically human. It is not an art for men in general, but for a very particular class of men, who may not be of more worth than the others, but who are apparently distinct.

There is one thing above all that it would be well to define. What do the majority of people call aesthetic pleasure? What goes on in their mind when a work of art 'pleases' them? There is no doubt about the answer: people like a work of art that succeeds in involving them in the human destinies it propounds. The loves, hates, griefs and joys of the characters touch their heart: they participate in them, as if they were occurring in real life. And they say a work is 'good' when it manages to produce the quantity of illusion necessary for the imaginary characters to rate as living persons. In poetry, they will look for the loves and griefs of the man behind the poet. In painting, they will be attracted only by those pictures where they find men and women who would be interesting to know. A landscape will appear 'pretty' to them when the scene represented merits a visit on account of its pleasant or emotive characteristics.

This means that for the majority of people aesthetic enjoyment is not an attitude of mind essentially different from the one they habitually adopt in other areas of life; but it is perhaps less utilitarian, more compact, and without unpleasant consequences. In essence, the object which concerns them in art, which serves as the focus of their attention and the rest of their faculties, is the same as in everyday life; human beings and their passions. And they will call art that which provides them with the means of making contact with human things. Thus they will tolerate certain forms of unreality and fantasy only to the extent that they do not interfere with their perception of human forms and situations. As soon as the purely aesthetic elements become dominant and detached from the human story, the public loses its way and does not know what to do before the stage, the book, or the picture. Understandably, people know of no other attitude when faced with such objects than that of habit, the habit of always becoming sentimentally involved. A work which does not invite this involvement leaves them without a role to play.

Now this is a point on which we must be clear. To rejoice or suffer with the human destinies which a work of art may relate or represent, is a very different thing from true artistic enjoyment. Indeed, such concern with the human element of the work is strictly incompatible with aesthetic gratification.

It is a perfectly simple matter of optics. In order to see an object we have to adjust our eyes in a certain way. If our visual accommodation is inadequate we do not see the object, or we see it imperfectly. Imagine we are looking at a garden through a window. Our eyes adjust themselves so that our glance penetrates the glass without lingering upon it, and seizes upon the flowers and foliage. As the goal of vision towards which we direct our glance is the garden, we do not see the pane of glass and our gaze passes through it. The clearer the glass, the less we see it. But later, by making an effort, we can ignore the garden, and, by retracting our focus, let it rest on the window-pane. Then the garden disappears from our eyes, and all we see of it are some confused masses of colour which seem to adhere to the glass. Thus to see the garden and to see the window-pane are two incompatible operations: the one excludes the other and they each require a different focus.

In the same manner, the person who seeks to involve himself, through a work of art, with the destinies of John and Mary or of Tristan and Isolde and adjusts his spiritual perception to these matters, will not see the work of art. The misfortunes of Tristan, as such, can only move us to the extent that they are taken for reality. But the artistic object is artistic only to the extent that it is not real. In order to enjoy Titian's equestrian portrait of *Charles V*, it is a necessary condition that we do not see the authentic, living Charles v but only a portrait of him, that is, an unreal image. The man portrayed and his portrait are two completely distinct objects: either we are interested in the one or in the other. In the former case, we 'associate' with Charles v; in the latter, we 'contemplate' the artistic object as such.

Now the majority of people are incapable of adjusting their attention to the window-pane which is the work of art; instead, their gaze passes through without lingering and hastens to involve itself passionately in the human reality to which the work alludes. If they are invited to let go this prize and focus their attention on the actual work of art, they will say they see nothing in it, because in fact they do not see in it human things, but only an 'artistic' nothingness.

Artists during the nineteenth century strayed too far from artistic purity, reducing to the minimum the strictly aesthetic elements and making their works consist almost entirely of this fictionalized version of human reality. In this sense it is therefore accurate to say that all the normal art of the past century has been realistic. Beethoven and Wagner

68

were realists; Chateaubriand, like Zola, was a realist. Romanticism and naturalism, seen from the viewpoint of today, come closer together and reveal their common root in realism.

Works of this nature are only partially works of art. In order to enjoy them we do not have to have artistic sensitivity. It is enough to possess humanity and a willingness to sympathize with our neighbour's anguish and joy. It is therefore understandable that the art of the nineteenth century should have been so popular, since it was appreciated by the majority in proportion to its not being art, but an extract from life. Remember that in all ages which have had two different types of art – one for the few and another for the many – the latter has always been realistic. In the Middle Ages, for example, corresponding to the twofold structure of society there was both an aristocratic art which was 'conventional' and idealistic, and a popular art which was realistic and satirical.

We will not discuss now whether pure art is possible. Perhaps it is not, but the reasons are somewhat tedious and in any case do not greatly affect the matter under discussion. Although a pure art may not be possible, there is no doubt that there is room for a movement towards it. This would lead to a progressive elimination of the human or too human elements characteristic of romantic and naturalistic works of art, and a point will be reached in which the human content of the work diminishes until it can scarcely be seen. Then we shall have an object which can be perceived only by those who possess that peculiar gift of artistic sensitivity. It will be an art for artists and not for the masses; it will be an art of caste, not demotic.

Here perhaps we have found the reason why the modern artist is dividing the public into two classes, those who understand and those who do not, that is artists themselves and those who are not. For modern art is an artistic art.

I am not seeking to extol this new manner of art and still less to denigrate the custom of the last century. I am limiting myself to classifying them. Modern art is a universal fact. During the last twenty years the most avant-garde of two successive generations in Paris, Berlin, London, New York, Rome, and Madrid have found themselves struck by the ineluctable fact that traditional art not only does not interest them; they actually find it repugnant. With these modern artists it is possible to do one of two things: either shoot them or make an effort to understand them. As soon as one decides in favour of the latter course one immediately notices a new conception of art germinating in their work which is quite clear, coherent and rational. Far from being a caprice, their striving is shown to embody the inevitable, and indeed fruitful outcome of all previous artistic evolution.

69

It is merely capricious, and thus sterile, to resist this new style and persist in immuring oneself within forms that are already archaic and hidebound. We have to accept the imperative of work which our era imposes; submissiveness to his own period offers the individual his only chance of achievement. Even so he may still attain nothing; but his failure is much more certain if he were to compose one more Wagnerian opera or yet another naturalistic novel.

In art all repetition is valueless. Each style in the history of art is able to engender a certain number of different forms within a generic type. But there comes a day when the rich mine is completely worked out. This has happened, for example, with the romantic and naturalistic novel and play. It is an ingenuous error to believe that the present-day sterility in both fields is due to lack of personal talent. What has happened is that all possible permutations have been exhausted. It is fortunate that the emergence of a new awareness capable of exploring unworked veins should coincide with this exhaustion.

Analysing the new style, one finds in it certain closely connected tendencies: it tends towards the dehumanization of art; to an avoidance of living forms; to ensuring that a work of art should be nothing but a work of art; to considering art simply as play and nothing else; to an essential irony; to an avoidance of all falsehood; and finally, towards an art which makes no spiritual or transcendental claims whatsoever.

With vertiginous speed modern art has diverged into a great variety of directions and intentions. It is easy to emphasize the differences between one work and another. But this will be valueless unless we first determine the common basis which, at times contradictorily, modern art shares. The specific differences in the arts today are of only moderate interest to me, and, apart from some exceptions, I am concerned still less with any one work. The important thing is that there is this new artistic awareness revealed not only in the artists themselves but also in some members of the public. When I said today's art exists primarily for artists, I meant not only those who produce it but also those who have a capacity for appreciating it. Now I shall outline which single characteristic of modern art seems to me to be of greatest importance: the tendency to dehumanize art.

If we compare a modern painting with one painted in, say, 1860, we can start by contrasting the objects represented in both works – perhaps a man, a house, or a mountain. We soon notice that the artist of 1860 has above all intended the objects in his picture to have the same air and aspect as when they form part of living reality. Possibly, also, the artist of 1860 may have sought other aesthetic implications, but the important thing to note is that he began by making sure of this external likeness. Man, house and mountain are immediately recognizable: they are our

old friends. On the other hand, these things in the modern painting require some effort before we can recognize them. The spectator may think that this painter is incapable of achieving a likeness. But the picture of 1860, too, may be 'painted badly' – that is to say, there may be a gulf between the objects in the picture and the reality they represent. Nevertheless, that reality is the goal towards which he stumbles. In the later painting, however, everything is the opposite: it is not a case of the painter making mistakes and so failing to achieve the 'natural' resemblance (natural here equals human): his deviations follow a road leading directly away from the human object.

The painter, far from stumbling towards reality, is seen to be proceeding in the contrary direction. He has set himself resolutely to distort reality, break its human image, dehumanize it. It is possible to envisage living in the company of the things represented in a traditional picture; association with the things shown in the new picture is impossible. In ridding them of their aspect of living actuality, the painter has severed the bridge and burnt the boats which might connect us with our customary world. He leaves us imprisoned in an abtruse world and forces us to confront objects impossible to treat humanly. We not only have to approach these paintings with a completely open mind; we have to create and invent almost unimaginable characteristics which might fit those exceptional objects. This new, invented life to which no spontaneous response can be gained from previous experience, is precisely what artistic comprehension and enjoyment is about. There is no lack in it of feelings and passions, but they belong to a psychic flora quite distinct from that which covers the landscapes of our primary and human life. They arouse secondary emotions which are specifically aesthetic.

It will be said that it would be simpler to dispense altogether with those human forms – man, house, mountain – and construct utterly original figures. But this, in the first place, is impracticable. In the most abstract ornamental line a dormant recollection of certain 'natural' forms may linger tenaciously. In the second place – and this is more important – the art of which we are speaking is not only not human in that it does not comprise human things, but its active constituent is the very operation of dehumanizing. In his flight from the human, what matters to the artist is not so much reaching the undefined goal, as getting away from the human aspect which it is destroying. It is not a case of painting something totally distinct from a man or a house or a mountain, but of painting a man with the least possible resemblance to man; a house which conserves only what is strictly necessary to reveal its metamorphosis; a cone which has miraculously emerged from what was formerly a mountain. The aesthetic pleasure for today's artist emanates from this triumph over the human; therefore it is necessary to make the

71

victory concrete and in each case display the victim that has been overcome.

It is commonly believed that to run away from reality is easy, whereas it is the most difficult thing in the world. It is easy to say or paint a thing which is unintelligible, completely lacking in meaning: it is enough to string together words without connection, or draw lines at random. But to succeed in constructing something which is not a copy of the 'natural' and yet possesses some substantive quality implies a most sublime talent.

'Reality' constantly lurks in ambush ready to impede the artist's evasion.

In works of art popular in the last century there is always a nucleus of living reality which ultimately forms the substance of the aesthetic body. It is upon this substance that art operates, embellishing that human nucleus, giving it brilliance and resonance. For the majority of people this is the most natural, indeed the only possible, structure of a work of art. Art is a reflection of life, it is nature seen through a temperament, it is the representation of the human, etc., etc. But the fact is that, with no less conviction, today's artists insist on the opposite. Why must the old always be counted right today, when tomorrow always agrees with the young against the old? Above all, it is useless to become indignant or make an outcry. Our most rooted and unquestioned convictions are those most open to suspicion. They demonstrate our limits and our confines. Life is of small account if it is not instinct with a formidable eagerness to extend its frontiers. One lives in proportion as one yearns to live more. The obstinate desire to remain within our habitual horizon points to a decadence of vital energies. The horizon is a biological line, a living organ of our being; while we enjoy plenitude the horizon stretches, expands, undulates elastically almost in time with our breathing. On the other hand, when the horizon becomes immovable it is a sign of a hardening of the arteries and the entry into old age.

It is not quite as evident as the academics assume that a work of art must necessarily contain a human nucleus for the Muses to bedeck and embellish. This would be to reduce art to mere cosmetics. I have already pointed out that the perception of living reality and the perception of artistic form are, in principle, incompatible since they require a different adjustment of our vision. An art that tries to make us see both ways at once will be a cross-eyed art. The works of the nineteenth century, far from representing a normal art, are perhaps the greatest anomaly in the history of taste. All the great periods of art have avoided making the human element the centre of gravity in the work of art. That demand for exclusive realism which governed the tastes of the past century precisely demonstrates an abberation without parallel in the evolution of aesthetics.

72

Whence it follows that the new inspiration, so extravagant in appearance, is again treading the true road of art, the road called 'the desire for style'. Now, to stylize is to distort the real, to make un-real. Stylization implies de-humanization. And, vice versa, there is no other manner of de-humanizing than stylization. Realism, on the other hand, invites the artist to follow docilely the form of things, invites him to abandon style. A Zurbarán enthusiast says that his pictures have 'character', just as Lucas or Sorolla, Dickens or Galdós, have character and not style. The eighteenth century, on the contrary, which has so little character, possesses style to saturation point.

Modernists have declared that the intrusion of the human in art is taboo. Now, human contents, the component elements of our daily lives possess a hierarchy of three ranks. First comes the order of persons, then that of other living creatures, and finally, that of inorganic things. Art today exercises its veto with an energy in proportion to the hierarchial altitude of the object. The personal, by being the most human of the human, is what is most shunned by the modern artist.

This can be seen very clearly in music and poetry. From Beethoven to Wagner, the theme of music was the expression of personal feelings. The lyric artist composed grand edifices of sound in order to fill them with his autobiography. Art was more or less confession. There was no other way of aesthetic enjoyment other than by contagion of feelings. Even Nietzsche said, 'In music, the passions take pleasure from themselves'. Wagner injects his adultery with La Wesendonck into *Tristan*, and leaves us with no other remedy, if we wish to enjoy his work, than to become vaguely adulterous for a couple of hours. That music fills us with compunction, and to enjoy it we have to weep, suffer anguish, or melt with love in spasmodic voluptuousness. All the music of Beethoven or Wagner is melodrama.

The modern artist would say that this is treachery; that it plays on man's noble weakness whereby he becomes infected by the pain or joy of his fellows. This contagion is not of a spiritual order, it is merely a reflex reaction, as when one's teeth are set on edge by a knife scraped on glass, an instinctive response, no more. It is no good confusing the effect of tickling with the experience of gladness. Art cannot be subject to unconscious phenomenon for it ought to be all clarity, the high noon of cerebration. Weeping and laughter are aesthetically fraudulent. The expression of beauty never goes beyond a smile, whether melancholy or delight, and is better still without either. *'Toute maîtrise jette le froid'* (Mallarmé).

I believe the judgment of the young artist is sound enough. Aesthetic pleasures may be blind or perspicacious. The joy of the drunkard is blind;

like everything, it has its cause, which is alcohol, but it lacks motive. The man who wins a prize in a lottery also rejoices, but in a different manner: he rejoices because of something definite. He is glad because he sees an object in itself gladdening.

All that seeks a spiritual, not a mechanical being will have to possess this clear-sighted character, intelligently motivated. Yet the pleasure a romantic work excites has hardly any connection with its content. What has the beauty of music to do with the melting mood it may engender in me? Instead of delighting in the artist's work, we delight in our own emotions; the work has merely been the cause, the alcohol, of our pleasure. And this will always happen when art is made to represent living realities; they move us to a sentimental participation which prevents our contemplating them objectively.

Seeing is action at a distance. A projector is operating within a work of art both moving things further away and transfiguring them. On its magic screen we contemplate them banished from the earth, absolutely remote. When this de-realization is lacking it produces in us a fatal vacillation: we do not know whether we are living the things or contemplating them.

We have all felt a peculiar unease in front of wax figures. This arises from the insistent ambiguity which inhabits them and which prevents our adopting a consistent attitude towards them. Treat them as living beings and they mock us by revealing their cadaverous and waxen secrets, yet if we look on them as dolls they seem to protest. There is no way of reducing them to mere objects. Looking at them, we become uneasy with the suspicion that it is they who are looking at us. And we end up by feeling loathing towards this species of hired corpses. The wax figure is pure melodrama.

To me it seems that the new attitudes are dominated by a loathing for the human in art very similar to the way in which discriminating men have always felt towards wax figures. These macabre mockeries, on the other hand, have always roused the enthusiasm of the common people. And, in passing, let us ask a few random questions, with the intention of leaving them unanswered for the time being. What does it signify, this loathing for the human in art? Is it by any chance a loathing of the human, of reality, of life – or is it perhaps the opposite, a respect for life and a repugnance for seeing it confused with anything as inferior as art? But what is all this about art being an inferior function – divine art, the glory of civilization, the pinnacle of culture, and so forth? I have said, these are random questions not pertinent to the immediate issue.

In Wagner, melodrama reaches its highest exaltation. And as always happens, when a form attains its maximum its conversion into the opposite at once begins. Already in Wagner the human voice is ceasing

to be a protagonist and is becoming submerged in the cosmic uproar of the other instruments. A conversion of a more radical kind was inevitable; it became necessary to eradicate personal sentiments from music. This was the accomplishment of Debussy. Since his day it has become possible to hear music serenely, without rapture and without tears. All the variations and developments that have occurred in the art of music in these last decades tread upon that extra-terrestrial ground brilliantly conquered by Debussy. The conversion from the subjective to the objective is of such importance that subsequent differentiations disappear before it. Debussy dehumanized music, and for that reason the era of modern music dates from him. His was the art of sound.

The same conversion took place in poetry. It was necessary to liberate poetry, which, weighed down with human material, was sinking to earth like a deflated balloon, bruising itself against the trees and rooftops. In this case it was Mallarmé who liberated poetry and gave it back its soaring power and freedom. Perhaps he himself did not quite realize his ambition, but as captain of the new space explorations he gave the decisive command: throw the ballast overboard.

Recall what used to be the theme of poetry in the romantic era. In neat verses the poet let us share his private, bourgeois emotions: his sufferings great and small, his nostalgias, his religious or political pre-occupations, and, if he were English, his pipe-smoking reveries. On occasions, individual genius allowed a more subtle emanation to envelope the human nucleus of the poem – as we find in Baudelaire, for example. But this splendour was a by-product. All the poet wished was to be a human being.

When he writes, I believe today's poet simply proposes to be a poet. Presently we shall see how all modern art, coinciding in this with modern technologies, science and politics, in short with life as it is today, loathes all blurred frontiers. It is a symptom of mental elegance to insist on clear distinctions. Life is one thing, poetry another, the young writer thinks – or, at least, feels. The poet begins where the man stops. The latter has to live out his human destiny; the mission of the former is to invent what does not exist. In this way the function of poetry is justified. The poet augments the world, adding to the real, which is already there, an unreal aspect. Mallarmé was the first poet of the nineteenth century who wanted to be nothing but a poet. As he himself says, he rejected 'nature's materials' and composed little lyrical objects, distinct from human fauna and flora. This poetry does not need to be 'felt', because, as there is nothing of the human in it, there is nothing of pathos in it either. If he speaks of a woman it is 'any woman', and if the clock strikes it is 'the missing hour on the clock face'. By a process of denial, Mallarmé's verse annuls all human echoes and presents us with figures so far beyond reality that

75

merely to contemplate them is a delight. Among such inhuman surroundings what can the man officiating as poet do? One thing only: disappear, volatilize and be converted into a pure, anonymous voice, which speaks disembodied words, the only true protagonists of the lyrical pursuit. That pure anonymous voice, mere accoustic carrier of the verse, is the voice of the poet, who has learnt how to isolate himself from the man he is.

From every direction we come to the same conclusion: escape from the human person. The processes of dehumanization are many. Perhaps today very different processes from those employed by Mallarmé dominate, and I am aware that even in his own works there still occur romantic vibrations. But just as modern music belongs to the era that starts with Debussy, all new poetry advances in the direction pointed out by Mallarmé. The link with both names seems to me essential if we wish to follow the main outline of the new style.

Today it is difficult for anyone under thirty to become interested in a book describing under the pretext of art, the behaviour of specific men and women. He relates this to sociology and psychology, and would accept it with pleasure if, not to confuse things, it were referred to as such. But art for him is something different.

Poetry today is the higher algebra of metaphors.

Metaphor is probably the most fertile of man's resources, its effectiveness verging on the miraculous. All other faculties keep us enclosed within the real, within what already is. The most we can do is add or subtract things to or from others. Only metaphor aids our escape and creates among real things imaginary reefs, islands pregnant with allusion.

It is certainly strange, the existence of this mental activity in man whereby he supplants one thing by another, not so much out of eagerness to achieve the one as from a desire to shun the other. Metaphor palms off one object in the guise of another, and it would not make sense if, beneath it, we did not see an instinct which leads towards an avoidance of reality.

A psychologist recently enquiring into the origin of metaphor discovered that one of its roots lay in the spirit of taboo. An object of ineffable importance would be designated by another name. The instrument of metaphor came later to be employed for the most diverse ends, one of them, the one that has predominated in poetry, being to ennoble the real object. Similes have been used for decorative purposes, to adorn and embroider the beloved reality. It would be interesting to find out whether, in modern art, on turning the metaphor into substance and not ornament, the image has not acquired a curiously denigrating quality, which, instead of ennobling and enhancing, diminishes and disparages

76

poor reality. A little while ago I read a book of modern poetry where lightning was compared to a carpenter's rule and winter's leafless trees to brooms sweeping the sky. The lyrical weapon is turned against natural things and damages, even assassinates them.

But, if metaphor is the most radical instrument of dehumanization, it cannot be said to be the only one. There are countless others of varying range.

The simplest consists in a mere change of the customary perspective. From the human point of view things have an order, a determined hierarchy. Some seem very important, others less so, others totally insignificant. In order to satisfy the urge to dehumanize it is not, therefore, necessary to alter the inherent nature of things. It is enough to invert this order of importance and make an art in which, looming up monumentally in the foreground, appear the events of minimum importance in real life.

This is the latent connection uniting apparently incompatible forms of modern art: the selfsame instinct of flight from the real is satisfied both in the surrealism of metaphor and in what might be called infra-realism. Reality can be overcome, not only by soaring to the heights of poetic exaltation, but also by paying exaggerated attention to the minutest detail. The best examples of this – of attending, lens in hand, to the microscopic aspects of life – are to be found in Proust, Ramón Gómez de la Serna, and Joyce.

As I have said, the purpose of this essay is merely to describe modern art by means of some of its distinctive features. But, in its turn, this intention finds itself serving a curiosity broader than these pages could satisfy, so that the reader is left to his private meditation. I refer to the following considerations.

Elsewhere* I have pointed out that art and pure science, precisely by being the freest of activities, and less dependent on social conditions, are the first fields in which any change in the collective consciousness can be seen. When man modifies his basic attitude to life he starts by manifesting this new awareness in both artistic creation and in scientific theory. The sensitivity of both areas makes them infinitely susceptible to the lightest breath of the winds of the spirit. As in a village, on opening the windows in the morning, we look at the smoke from the chimneys in order to see which way the wind is blowing so we can look at the arts and sciences of the younger generations with a similar meteorological curiosity.

But in order to do this it was essential to define the new phenomenon.

* Ortega y Gasset's *The Modern Theme*, London 1931, New York 1961.

Having done so, only now can we ask what new life-style modern art heralds for the future? The reply would entail investigation into the causes of this strange change of direction which art is making, and this in turn would be an enterprise too weighty to undertake here. Why this urge to dehumanize, why this loathing of living forms? Probably, like every historical phenomenon, its roots are so tangled only the subtlest detection could unravel them.

Nevertheless, one cause stands out quite clearly, although it cannot be regarded as the decisive one.

The influence of its own past on the future of art is something that cannot be over-stated. Within the artist there goes on a constant battle, or at least a violent reaction, between his own original experiences and the art already created by others. He does not find himself confronting the world on his own; artistic tradition, like some middleman, always intervenes. He may feel an affinity with the past, regarding himself as the offspring who inherits and then perfects its traditions – or, he may discover a sudden indefinable aversion to the traditional and established artists. Should he fall into the first category he will experience pleasure in settling into the conventional mould and repeating most of the sacred rituals: if in the second he will find the same intense pleasure in giving his work a character aggressively opposed to established standards.

This is apt to be forgotten when people talk of the influence of yesterday upon today. It is not difficult to recognize in the work of one period the desire to resemble that of the preceding one. On the other hand, almost everybody seems to find it difficult to see the negative influence of the past, and to note that a new style is often formed by the conscious and complicated negation of traditional modes.

And the fact is that one cannot understand the development of art, from Romanticism to the present day, unless one takes into account that negative mood of aggressive derision as an ingredient of aesthetic pleasure. Baudelaire praises the black Venus precisely because the classical one is white. From then on, successive styles have been progressively increasing the negative and blasphemous content in things that tradition once delighted in, up to the point where today the profile of modern art consists almost entirely of a total negation of the old. That this should be so is understandable. Many centuries of continuous evolution in art, unbroken by historical catastrophes or other serious interruptions, produce an ever-growing burden of tradition to weigh down inspiration. Or, to put it another way: an ever-growing volume of traditional styles intercept direct communication between the emergent artist and the world around him. One of two things may happen: either the tradition will end by overwhelming all original talent – as was the case in Egypt, Byzantium, and the East in general – or the burden of the past upon the

present will be thrown off, followed by a long period in which the arts gradually break free from the traditions that were smothering it. This has been the case in Europe, where a futurist instinct is overthrowing a positively oriental reverence for the past.

A large part of what I have called 'dehumanization' and the loathing of human forms arises from this antipathy to the traditional interpretation of reality. The vigour of the attack is in indirect ratio to the distance in time: what most repels the artists of today is the predominant style of the past century, despite the fact that it contained its own measure of opposition to older styles. On the other hand, the new artist apparently feels an affinity towards art more distant in time or space – the prehistoric the primitive and exotic. What is probably found pleasing in these primitive works is – more than the works themselves – their ingenuousness and the absence of any recognizable tradition in them.

If we now consider what attitude to life this attack on the artistic past indicates, we are confronted by a revelation of immense dramatic quality. Because, ultimately, to assault the art of the past is to turn against *art* itself; for what else in actual fact is art, but a record of all that the artist has achieved up to the present?

Is it then the case that, under the mask of love there is hidden a satiety of art, a hatred of art? How would that be possible? Hatred of art cannot arise except where there also prevails hatred of science, hatred of the state, hatred, in short, of culture as a whole. Does Western man bear an inconceivable rancour towards his own historical essence? Does he feel something akin to the *odium professionis* of the monk, who, after long years in the cloister, is seized with an aversion to the very discipline which has informed his life?

It would be interesting to analyse the psychological mechanisms by means of which the art of yesterday negatively influences the art of tomorrow. One of these – *ennui* – is clearly evident. The mere repetition of a style blunts and wearies the senses. Wölfflin has shown, in his *Fundamental Concepts in the History of Art*, the power that fatigue has had time and again in mobilizing and transforming art.

Earlier on it was said that the new style, taken in its broadest general aspect, consists in eliminating ingredients that are 'too human', and retaining only purely artistic material. This seems to imply a great enthusiasm for art. But, on contemplating this same fact from another angle, we discover in it a contradictory aspect of loathing or disdain. The contradiction is obvious, and must be stressed. Apparently, modern art is full of ambiguity – which is not really surprising, since almost all important contemporary issues have been equivocal. One has only to do a brief analysis of the recent European political developments to find

in them the same intrinsic ambiguity. However, this paradoxical love and hate for the selfsame object is somewhat easier to understand if we look more closely at contemporary works of art.

The first result of art's withdrawal into itself is to rid it of all pathos. Art, with its burden of 'humanity', used to reflect the grave character of life itself. Art was a very serious matter, almost hieratic. At times it aspired to nothing less than saving the human species – as in Schopenhauer or Wagner. Anyone bearing these examples in mind cannot but find it strange that modern inspiration is always, unfailingly, comic. The comic element may be more or less refined, it may run from frank buffoonery to the subtle wink of irony, but it is never absent. It is not that the content of the work is comic – that would be to fall back into the category of the 'human' style – but that art itself makes the jest, whatever the content. As previously indicated, to look for fiction as nothing else but fiction is an intention that cannot be held except in a humorous state of mind. One goes to art precisely because one recognizes it as farce. This is what serious people, less attuned to the present, find most difficult to understand in modern art. They think that modern painting and music are pure 'farce' – in the pejorative sense of the word – and cannot admit the possibility that art's radical and benevolent function might lie in farce itself. It would be 'farce' – again in the bad sense – if the artist of today pretended to compete with the 'serious' art of the past, or if, say, a cubist painting attempted to solicit the same type of emotional, almost religious admiration as a statue of Michelangelo. But the modern artist invites us to contemplate an art that is a jest *in itself*. For from this stems the humour of this inspiration. Instead of laughing at any particular person or thing – there is no comedy without a victim – modern art ridicules art.

One need not become too alarmed at this. Art has never better demonstrated its magical gift than in this mockery of itself. Because it makes the gesture of destroying itself, it continues to be art, and, by a marvellous dialectic, its negation is its conservation and its triumph.

I very much doubt if young people today could be interested in a verse, a brushstroke or a sound which did not carry within it some ironic reflection.

After all, this is not a completely new theory. At the beginning of the nineteenth century a group of German romantics led by the Schlegels proclaimed irony as the highest aesthetic category, and for reasons which coincide with the intentions of modern art. Art is not justified if it limits itself to reproducing reality, to vain duplications. Its mission is to conjure up an unreal horizon. To achieve this we can only deny our reality and by so doing set ourselves above it. To be an artist is not to take man as seriously as we do when we are not artists.

Clearly, this quality of irony gives modern art a monotony which is highly exasperating. But, be that as it may, the contradiction between hate and love, surfeit and enthusiasm, now appears to be resolved. Hate is aroused when art is taken seriously, love, when art succeeds as farce, laughing at everything, including itself.

There is one feature of great significance which seems to symbolize all that modern art stands for – the fact that it is stripped of all spiritual content. Having written this sentence, I am astonished to find the number of different connotations it carries. The fact is not that the artist has little interest in his work, but that it interests him precisely because it does not have grave importance, and to the extent that it lacks it. The matter will not be properly understood if it is not considered together with the state of art thirty years ago, indeed, throughout the past century. Poetry and music were then activities of immense importance: little less was expected of them than the salvation of the human species amid the ruin of religions and the inevitable relativism of science. Art was transcendent in a noble sense. It was transcendent by reason of its themes, which included the most serious problems of humanity, itself lending justification and dignity to humanity. This was to be seen in the solemn stance adopted by the great poet or musician, the posture of a prophet or the founder of a religion, the majestic attitude of a statesman responsible for the destiny of the universe.

I suspect that an artist of today would be appalled to see himself appointed to such an enormous mission and thus obliged to deal with matters of comparable magnitude in his work. He begins to experience something of artistic value precisely when he starts to notice a lightness in the air, when his composition begins to behave frivolously, freed of all formality. For him, this is the authentic sign that the Muses exist. If it is still proper to say that art saves man, it is only because it saves him from the seriousness of life and awakens in him an unexpected youthfulness. The magic flute of Pan which makes the Fauns dance at the edge of the forest is again becoming the symbol of art.

Modern art begins to be understandable, acquiring a certain element of greatness when it is interpreted as an attempt to instill youthfulness into an ancient world. Other styles insisted on being associated with dramatic social or political upheavals or with profound philosophical or religious currents. The new style, on the contrary, asks to be associated with the triumph of sports and games. It shares the same origins with them.

In the space of a few years, we have seen the tidal wave of sport all but overwhelming the pages of our newspapers that bear serious news. Articles of depth threaten to sink into the abyss their name implies, while the yachts of the regattas skim victoriously over the surface. The

cult of the body eternally speaks of youthful inspiration, because it is only beautiful and agile in youth, while the cult of the mind implies an acceptance of growing old, because it only achieves full maturity when the body has begun to fail. The triumph of sport signifies the victory of the values of youth over the values of old age. The same is true of cinema, which is *par excellence* a group art.

In my generation the manners of middle-age still enjoyed great prestige. A boy longed to stop being a boy as early as possible and preferred to imitate the jaded airs of the man past his prime. Today, little boys and girls try hard to prolong their infancy, and the young strive to retain and accentuate their youthfulness.

This should cause no surprise. History moves in accord with great biological rhythms, its greatest changes originating in primary forces of a cosmic nature. It would be strange if the major and polar differences in human beings – the differences of sex and age – did not also exercise an influence upon the times themselves. And, indeed, it can be clearly seen that history swings rhythmically from one to the other pole, at certain times stressing the masculine qualities, in others the feminine, at certain times exalting the spirit of youth and at others that of maturity.

Today, the predominant aspect in all stages of European existence is one of masculinity and youth. Women and the elderly must for a period yield the government of life to the young men, and it is no wonder that the world appears to be losing formality.

All the characteristics of modern art can be summed up in these basic attitudes, which in their turn are responding to art's changed position in the hierarchy of human preoccupations. I would say that art, previously situated, like science or politics, very close to the hub of enthusiasm, that chief support of our personal identity, has moved out towards the periphery. It has lost none of its exterior attributes, but has made itself secondary, less weighty, more remote.

The aspiration to pure art is not, as is often believed, an act of arrogance, but, on the contrary, of great modesty. Art, having been emptied of human pathos, remains without any other meaning whatsoever – as art alone, with no other pretension. Isis of a myriad names, the Egyptians called their goddess. All reality has a myriad aspects. Its components, its features, are innumerable. It would be a remarkable coincidence if, out of an infinity of possibilities, the ideas we have explored in this essay, should turn out to be the correct ones. The improbability increases when we are dealing with a new-born reality, one only at the beginning of its journey through space.

It is, therefore, highly probable that this description of modern art contains nothing but errors. Having concluded my attempt, I am curious and hopeful to find whether others of greater accuracy will follow it. It

would only confuse the issues if I were to try to correct any errors I have made by singling out some particular feature omitted from this analysis. Artists are apt to fall into this error when they talk about their art and do not stand far enough away to take a broad view of the facts. I have been moved solely by the pleasure of trying to understand – not by anger or enthusiasm. I have endeavoured to seek the meaning of the intentions of modern art, and this obviously pre-supposes a benevolent state of mind.

It is surely not possible to approach a theme in any other manner without condemning it to sterility?

It will be said that the new art has not produced anything worthwhile up to now, and I come very close to thinking the same. From existing works I have been trying to extract an intention and I have not concerned myself with their fulfilment. Who knows what will come out of this new order! The enterprise is fabulous – it seeks to create out of nothing. I hope that later on it will be content with less and achieve more.

But, whatever its errors may be, there is in my opinion one immovable point in the new situation: the impossibility of going back. All the objections levelled at the inspiration of these artists may be correct, but they still do not contribute sufficient reason for condemning it. Something positive would have to be added: the suggestion of another road for art which would neither dehumanize nor retravel the roads already used and abused.

It is very easy to cry that art is always possible within the tradition. But this comforting phrase is useless for the artist who awaits, with brush or pen in hand, a concrete inspiration.

Introduction to Velazquez
1943

Velazquez was born in 1599, Ribera in 1591, Zurbarán in 1598, Alonso Cano in 1601, Claude Lorraine in 1600, Poussin in 1593, Van Dyck in 1599. All these famous painters belong to the same generation. Contemporary Spanish writers include Calderón, born in 1600, and Gracián, born in 1601. Also of this generation was Descartes, born in 1596.

Velazquez' life is one of the simplest a man can ever have lived. Considering his stature as an historical figure, it is surprising we possess such little biographical information. The historian tends to have an insatiable appetite for data, the reason being that he generally tries to avoid taxing his brain, preferring history to build itself up spontaneously, fact upon fact. But the truth is that although we might possess every imaginable piece of information we should not have history, and that with much less than we now have it would be possible for something resembling, however remotely, the History of Man to exist.

In the case of Velazquez, the scarcity of data has a curious character. We know little of his life, but that little shows us that in fact we do not need to know more, because it suffices to reveal that in all his life only one thing of importance – among those verifiable by data – happened to him: his appointment as painter to the king at the very start of his career. That was in 1623, when he was barely twenty-four years old. The rest of Velazquez' known life was humdrum in the extreme. Three other events which broke the monotony of his existence – he died at the age of sixty-one – are well-known: his meeting with Rubens, who was in Madrid for eight months in 1628–9, and his two visits to Italy, in 1629 and 1649.

While these three events are certainly not without significance, they are not of true importance. An event is important when, if we were to omit it in making an imaginary biographical reconstruction, it forces us to modify, again in our imagination, the pattern of that life. This is what would happen if we envisaged Velazquez as not having been nominated court painter, or as not having attained that honour and position until much more advanced in years. We would then have another Velazquez; of what kind, we shall consider presently. It is as if we had imagined a Goethe without Weimar. But there is nothing to lead us to believe that without the two journeys to Italy the life and work of Velazquez would have been different. The only consequence would have been the omission

of *Vulcan's Forge, Joseph's Coat brought to Jacob,* and *The Temptation of St Thomas Aquinas* – the three most equivocal pictures in his entire oeuvre, since they constitute a strange digression without connection with what preceded and what followed them. The only clear effect of those journeys that we notice in Velazquez is that he returned from them refreshed, like someone coming back from an open-air cure.

Of great influence was the encounter with Rubens, which facilitated his inner liberation by helping him break through the mesh of provincialism which enveloped Spanish life at that time, despite the fact that Spain was still the dominant world power. But no one who has attempted to build up with any accuracy a picture of Velazquez the man can doubt that it would not have taken him much longer to break this inhibiting web of his own initiative. In him we have one of those men most secretly resolved to exist only from within, to obey only their own resolutions, which were of the most tenacious and unalterable kind.

With these reservations, one may say that Velazquez' life falls naturally into the following four periods:

1599–1623

Diego de Silva Velazquez was born in Seville, of a family of Portuguese origin on the father's side, the Silvas of Oporto. The grandfather had emigrated to Andalucia, bringing with him a moderate amount of goods and an intense family tradition of ancient and exalted nobility. Very early on Diego displayed extraordinary gifts for drawing and painting. At the age of thirteen he entered as a pupil the workshop of Francisco de Herrera, an irascible man and an artist of more impetuosity than talent. A few months later, driven away no doubt by the ferocious temperament of this teacher, Velazquez, who all his life detested quarrels, moved to the studio of Francisco Pacheco, which was like going from one polar extreme to the other. Pacheco was a mediocre painter but an excellent man, of wide culture, gentle manners, and acquainted with the distinguished society of Seville – artists, writers and noblemen. Five years later – in 1618 – the young Velazquez married Pacheco's daughter, Juana de Miranda. This woman quietly accompanied him throughout his life, and we know of no other involvement on Velazquez' part with any other woman. Juana de Miranda died one week after her husband, in the same room where he died.

1623–1629

In 1621 Philip III died and was succeeded by the young Philip IV, who was six years younger than Velazquez and himself fond of painting, which he had practised under the instruction of Mayno. Philip IV placed

the government in the hands of the Conde-Duque de Olivares,* a member of the most ancient and exalted Sevillian family of the Guzmanes. Like the heads of state in every age, on coming to power the Conde-Duque surrounded himself with his own select group of followers. His friends were from Seville, and were the friends of Pacheco. Velazquez was sent to Madrid to try his luck and in passing enlarge his artistic education by visiting the collections of Madrid and the Escorial. The political change had been too recent, conditions in the palace were too unsettled, and no occasion presented itself for Velazquez to shine before the new monarch. He did, however, paint a wonderful portrait of the poet Góngora. With hopes dashed, Velazquez returned to Seville, but a few months later he was officially summoned to the palace, (his travelling expenses defrayed). In the *entourage* of the Conde-Duque, Velazquez was to represent the art of painting. He reached Madrid, and at once made a portrait of the king. The work roused such enthusiasm in Philip IV that he instantly made Velazquez his court painter and vowed not to let himself be portrayed by anyone else. Henceforth, Velazquez would always be attached to the palace, and it would be from one of the royal apartments that they would take him to be buried. Bear this in mind: only one woman is visible in his life; only one friend – the king; only one workshop – the palace.

From this moment, which is when it really begins, Velazquez' life presents the spectator with a radical ambiguity: it is not clear whether it is the life of a painter or that of a courtier. Regularly, one after the other, he will continue to receive appointments and positions, up to the supreme dignity of *aposentador mayor*, and culminating in his being made a Knight of the Order of Santiago – that is, with ennoblement.

In 1628 Rubens arrived in Madrid, at the summit of his universal fame. He had been sent by the Archduchess Governor of the Netherlands, the aunt of Philip IV, to undertake a diplomatic mission concerning the king of England. It is important to stress the affairs of state in which painters were involved at that time, because they reveal better than anything else the social power which painting had come to enjoy in European society, and only this exuberance of prestige will explain to us certain paradoxical qualities in Velazquez' works.

Velazquez was Rubens' companion during the eight months of his stay in Madrid. He was the first great European artist with whom Velazquez had come into contact; in him chance had combined man of the world, great entrepreneur and politician along with a style of living proper to a great gentleman. Such a personage made Velazquez see that the world, including the world of art, was greater than he had hitherto realized. This association with the Fleming may have encouraged

* The Conde-Duque (Count-Duke) was First Minister to Philip IV.

him to get away from Spain for a while and see other countries. He embarked at Barcelona on 10 August, 1629, with Genoa as his destination. On the same voyage sailed Ambrosio de Spinola, the victor of Breda.*

1629–1649
Genoa, Milan, Venice, then down through Bologna. He visits Loreto, where three years previously Descartes had been, in fulfilment of a promise made to the Virgin for having received the inspiration of analytical geometry. Finally, Rome and Naples, in which city he makes the acquaintance of Jusepe Ribera, the Spanish painter.

In 1630 he returns to Spain, and his life to 1649 follows a straight line, where one day much resembles the next. Twenty years represents many, many hours. What does Velazquez do with them? He paints, that goes without saying. But if we wish to see clearly who this man is, we must move through his life-story with the utmost alertness. For at once we run up against this important paradox: Velazquez is the painter distinguished not so much by his painting, but rather by the *little* that he paints. This fact, like other apparently negative features in his life which we shall presently note, is of the essence. So little did he paint that Palomino, his first biographer and almost his contemporary, and after him all the rest of his biographers up to the present day, have felt obliged to account for this parsimony and have attributed it, above all in the last ten years of his life, to the time lost to his other court occupations. Indeed, from his first return from Italy, we do see him becoming more and more involved in the arrangement and adornment of the king's houses. In the years between 1630 and 1640 the Palace of the Buen Retiro was built, and the Alcazar and the palace of El Pardo reconstructed. Nevertheless, these occupations did not take up too much time. One cannot possibly suppose they involved a greater loss of time than that represented in the life of any ordinary painter by his having to execute tasks of no artistic interest, such as making copies of his original works. Velazquez was free of all that. He accepted no commissions whatsoever. He painted only what the king commanded, and the king gave him very few commands. I must disagree with the biographers and assert that no painter has ever had more time than Velazquez. Therefore the cause of the paucity of his production must lie elsewhere. It cannot be attributed, either, to slowness in painting. Quite the contrary. Velazquez painted the greater part of his work *alla prima*, without the complicated preparations usual to other painters. He did not even draw the figures. Right from the start, he attacked the empty canvas with the brush and

* The Spanish victory at Breda was to be the subject of Velazquez' famous painting *The Surrender of Breda* (Las Lanzas).

brought the picture into life. His painting was so rapid that these same biographers, with exemplary ingenuity, wish to explain by his lack of time not only that he painted little, but his actual method of painting. He built up the picture with a few brushstrokes. At times there are portions of the canvas left bare of pigment and the colour of the canvas functions as a colour of the picture. In his last period particularly, the reduction of brushstroke is such that it has been called the *manera abreviada* (abbreviated style).

We know that he painted rapidly, but we also know, from something said by an Italian ambassador, that he was well known for his slowness in finishing and delivering his pictures, not because they gave him much trouble to do but because he worked very little at them, forgetting about them. Moreover, the majority of Velazquez' paintings are left unfinished. All of which is surprising, and enigmatic. Velazquez, short of time? Velazquez, in a hurry? Certainly, the hours of human existence are numbered, and in this sense life is supremely urgent. But, for that very reason, nothing distinguishes each human individual so profoundly as the way he conducts himself before this essential urgency, his way of coping with it. There are those who, being in haste as we all are, are not in a hurry. There are those who react to the urgency of existence by denying it, that is to say, by filling it with calm. This implies that such a person is not avid for life. For many reasons and in many senses I see in Velazquez one of those men with the most exemplary understanding of . . . non-existence. On his second journey to Italy, he stayed two years. In view of the fact that he made no move to return, Philip IV, the man who had spent most hours in Velazquez' company, wrote in his own hand to his ambassador, the Duque del Infantado, insisting that he put pressure on Velazquez to make him return immediately, 'because,' he said, 'you know his phlegm'. But phlegm is the superlative of calmness, and the phlegmatic man is the multi-millionaire of time, having it always in excess.

The biographer of Velazquez has no other remedy than to devote himself *à la recherche du temps perdu* by the painter.

It is often the case that painters, in whom there lingers something of the admirable background of the artisan, the manual worker, are taciturn men, and we know of Velazquez that he was taciturn in the extreme. He had certain companions, very few, of his own profession, with whom he associated when they came to Madrid: Alonso Cano, Zurbarán, and one or two others. But it should be noted that these were friends of his youth. New friendships do not occur in the life of Velazquez. He was melancholic, so Palomino tells us. He was uncommunicative. He was withdrawn. The principal proof of his having spent very little time in social intercourse is that only thus can we explain the most extraordinary

fact that he was spoken of very little during his lifetime. It is natural that little was said about Zurbarán, who passed almost the whole of his life buried in out-of-the-way monasteries. But Velazquez was a member of the court and lived in the palace, and it is well known that the king considered him and treated him as a personal and intimate friend. Yet nobody bothered about him. Once Quevedo devoted three or four words to his mode of painting, and that is all. But Quevedo was the only writer of whom, after his installation in Madrid, he made a portrait, probably at the suggestion of the Conde-Duque. Thus even this exception loses positive value and serves only to emphasize the silence of writers on the topic of Velazquez.

Historians of famous men should endeavour to portray with the greatest possible accuracy the nature of their fame whilst they were alive, since few other things are so important. It is not a case of being famous in general and in the abstract. Every reputation has its strict profile. Having been appointed court painter at such an early age would have sufficed to have made Velazquez famous. And, in fact, that sudden triumph resounded like thunder. But, for that very reason, it immediately caused all the serpents of Envy to come sliding out of their black holes. From then on, the countless legion of the envious would lay siege to Velazquez' fame. They could not allow themselves violent onslaughts, because the king protected the painter, towards whom he felt not only admiration but profound friendship. The strategy of Envy consisted in stinting the renown as it was growing. For this purpose it employed its two unfailing methods. In view of the fact that every portrait painted by Velazquez in this his first period was better than the preceding one and left infinitely far behind all then being done, the envious ones said he was incapable of painting anything but portraits. This is one of the recognized methods by which Envy seeks to diminish the fame of the man of talent. The other consisted in organizing a conspiracy of silence on the matter, so that Velazquez was talked of as little as possible.

The conduct of our painter in face of this unceasing labour of Envy is typical. He ignores it; he does not concern himself with it, unless we call disdain concern. Velazquez was a genius in the matter of disdain. Few men have succeeded in disdaining so entirely, so naturally, as Velazquez. When it happened that Envy drew too close to him, making some retort unavoidable, then Velazquez would bare his teeth like a lion. His sallies were known to be devastating. One day, not long after his being appointed court painter, Philip IV, concerned that he should defend his reputation, told him that people were saying he only knew how to paint heads. At this, the young and amiable Velazquez tossed his great black mane of hair and replied, 'Sire, then they do me great honour, for up to now I have not seen a well-painted head.' It is one of the three or

four utterances of the artist's that have come down to us, and, like the others, in its pithy brevity it informs us at once as to his character, the clear conscience with which he followed his artistic purpose, and the pictorial intention which guided him.

Not only did he not bother to protect himself from Envy, but he never took a step towards propagating and consolidating his renown. His relationship with his work was reduced to creating it, and he was concerned with his talent only when making it function. No one was more averse to publicity and intrigue. He lived aloof from all parties and cliques, something not at all easy in a palace.

From all this resulted the strange state of his reputation during his lifetime. In Spain, and from the start, this was inevitably of great extent. Notwithstanding, we might wander through that period without scarcely ever stumbling upon it. Although great, it was a tenuous, inactive, somewhat static fame. It did not radiate, it did not produce effects, and, while the word 'fame' signifies 'giving occasion for speaking', round about Velazquez they kept quiet. It is very important to make clear that Velazquez was not 'popular' in his time. He did not have a good press. For this there were substantive reasons which we will go into presently, but it is apposite to dwell on the 'too human' side of the matter, not only because it shows us what sort of man Velazquez was, but because it gives an unsurpassable example of what is the fame of an artist or a writer when it is pure, that is, when he renounces publicity and intrigue.

1649–1660

From 1640, a strong nostalgia for Italy periodically awoke in Velazquez' soul. There was nothing exceptional about this: from 1550 the young painters of the Netherlands, Germany and France had been visiting Italy, the glowing image of that country haunting their memories for the rest of their lives. Although everywhere art had come to impose itself like a new social power over the governing classes, only in Italy was it a public reality which walked through the streets and formed part of the atmosphere. Hence every artist felt himself a citizen of Italy, and an exile when away from her. But I am not very sure that this was the motive for the nostalgia which from time to time ached in Velazquez' heart. We would be doing wrong to interpret his relationship with art in a simple and topical manner. The beatification of art repelled him, and certain indications lead us to suspect that he found the 'typical artist' insufferable.

It seems more probable that what attracted him about Italy was its general *modus vivendi*, in which art was only one ingredient. It was in fact the most modern way of life to be found at that time in Europe: a

free life, without provincialism, of wide horizons, yet further extended by luminous memories of cosmopolitan antiquity.

But Philip IV did not allow him to return to Italy until 1649. Increasingly resolved to build up the finest collection of pictures, he at last sent Velazquez to acquire as many as possible, an intention all the more remarkable in that the king had no money. The result of his efforts is the Prado Museum of today.

This second journey of Velazquez was of an official character. He went as special envoy from the most powerful monarch – one who, furthermore, treated him as a personal friend. Thus it was that on this visit the Italian artists witnessed the arrival of a noble *caballero*, a great gentleman named Velazquez. Such is the impression we get from those who had dealings with him in Rome and Venice at that time.

On the completion of his portrait of Innocence X, the pope sent him by way of remuneration a chain of gold. Velazquez made the unheard of gesture of returning the chain, letting it be known that he was not a painter but a servant of his king, whom he served with his brush when he received orders to do so. This solemn gesture with which Velazquez repudiated his professional role illuminates all his earlier life. The secret truth of his whole life, the enormous paradox is revealed more and more distinctly. Velazquez did not wish and never had wished to be a painter. This should be enough to make us understand why he painted so little, without the need of resorting to explanations such as lack of time.

He returned to Madrid in 1651. In 1652 he applied for the post of *Aposentador mayor*, one of the highest positions in the palace, customarily held by persons of noble birth. In 1658 the king signified his willingness to requite his services and long friendship, bestowing on him the robes of the Military Orders, which involved a title. Velazquez chose the Order of Santiago, and took proceedings for proof of the purity of his blood and the nobility of his family. Each fresh piece of evidence makes clear that Velazquez had never practised painting as a profession, that he had always lived with the decorum and attitude of a nobleman, that his painting was a gift, a 'grace', and not a means of living.

In 1660, discharging the duties of his new position, he was to direct the journey of Philip IV to the Pyrenees, when the latter delivered his daughter Maria Teresa to Louis XIV as his bride. The ceremony took place on the Isle of Pheasants in the middle of the River Bidasoa, neutral territory between France and Spain. The nobility of both countries were gathered there in all their jewels and finery. Among the memories of that historic day preserved by those present, both French and Spanish, the impression produced by the presence of Velazquez stands out. One week later, no sooner returned to Madrid, the great painter would die. But at that purely royal festival Velazquez enjoyed his greatest triumph. It is

a strange one, but for that very reason interests us greatly. It was the physical triumph of his personal excellence, his aristocratic elegance, his lordly bearing. It is well for us to retain this image like a reflected light, while we contemplate his pictures.

Part II

This, in broad terms, is what usually is considered to be Velazquez' biography. But clearly it is not that. It is merely a collection of external data. But life is par excellence intimacy, that reality which exists only for itself and therefore can only be seen from its interior. If we change the viewpoint and pass from outside to within, then the spectacle is completely transformed. Life ceases to be a series of events occurring with only a chronological connection, and appears to us as a drama, as a tension, a dynamic process whose development is perfectly intelligible. The argument of the drama consists in a man struggling to make real, in the world he encounters at birth, the imaginary personage who constitutes his true self. He has to bring into being a certain individual figure of humanity, a certain programme of life peculiar to himself. This ideal personage within each one of us is called 'vocation'. Our vocation collides with circumstances, which may aid or impede it. Vocation and circumstance are thus two given dimensions which we can define with precision and understanding, the one confronting the other. But in this intelligible system there intervenes an irrational factor: chance. Thus we can reduce the components of every human life to three great factors: vocation, circumstance, and chance. To write a man's biography is to succeed in placing these three values in equation. But although chance is the irrational element of life, in a well-constructed biography we should be able to define which of his acts and characteristics proceed from chance and which do not, according to how deeply it penetrates the life-pattern.

Velazquez came of a noble family which had emigrated and become impoverished, and in which moreover the preoccupation with their lineage must have been obsessive. In their hearts the legend persisted that the Silva family stemmed from no less a person than Aeneas Sylvius, king of Alba Longa. But fortune had been cruel, and in their present circumstances the glorious family tradition was stylized and sublimated in myth and religion. In the initial and deepest layer of his soul, Velazquez found this commandment: 'You must be a nobleman'. But for the time being this incentive was schematic, remote and impracticable. Nearer to hand, more concrete, he discovered at the very threshold of his life a magnificent possibility: his incredible talent for painting. Velazquez, we must bear in mind, was an infant prodigy. This of course is no guarantee

of becoming a great artist, but he possessed this innate capacity right from the start and with an almost fabulous intensity. In a few years, while still adolescent, these gifts developed astoundingly and kept him, up to the age of twenty, in an effervescence and near frenzy of work which, once his authentic personality as a man had awakened, he would not feel again. In this first stage, his magical faculties drew him on and compelled him to work incessantly. His father-in-law has unwittingly left us a picture of those prodigious years of happy abnormality.

By itself, the perfection he achieved in boyhood would have lacked importance to his biographers, but it is significant because of two effects which it produced, the first being to make him enter life with a feeling of superlative security. Very early on Velazquez knew he had left all the painters of his epoch behind him. He was never vain or conceited but words he spoke towards the end of his Sevillian period prove he was already perfectly convinced of his superiority. His authentic personality not having yet awakened, Velazquez thought at that time his destiny was to be a painter – and almost before he had decided to be one, found he had outdistanced all his contemporaries.

The other effect of his precocious talent was that it permitted him, before maturity, to take advantage of the pure chance represented by the change of king and the exaltation of the Conde-Duque de Olivares. The fact that Velazquez entered the palace when he had not even started to make his way in the world was to shape his entire life, and this means that it would both mould it and mar it. Without a doubt, it was a prodigious stroke of good fortune to which are owed some of the purest qualities his work possesses. But chance is always the inorganic element of life, and it is very hard for such an intervention not to bring, together with favourable influences, some of a more harmful nature.

Let us note, above all, the most radical effect it produced in Velazquez. The imperative family call to noble destiny which, from the improbability of its realization, had remained latent in Velazquez, immediately flared up with great ardour. For a man of that time with pretensions to nobility, serving the king was, next to serving God, the supreme ideal of existence. And the youthful Velazquez was going to serve a king more youthful still, and in a capacity which would involve the closest contact with the royal presence. In his career as a nobleman, this was equivalent to starting at the finish, to achieving all from the very beginning, without effort or patient endeavour.

The consequence was that Velazquez awoke to his authentic vocation. He rejected with horror the idea of dedicating himself to painting as a profession. He would be a gentleman who, from time to time, painted a little.

Let us enumerate the advantages this sudden and early favour of fortune produced in his life:

1 From the outset, it freed him from the pressures and obligations which painting as a profession imposes on creative activity. Velazquez would be exempt from the need of attending to commissions given by churches, monasteries, municipalities and rich amateurs.

2 Thus, apart from the obligation of making portraits of the royal family, for him painting was converted into the pure pursuit of art. I do not believe that any other painter has been in this situation prior to the nineteenth century. Pure art, art as something of real and independent importance in itself, is a relatively normal phenomenon of today. In this matter, so essential and fundamental to his style, Velazquez already represents and anticipates our times. Consequently, with each one of his canvases, apart from the royal portraits, we always have to ask ourselves why he painted it, and the answer is almost always a matter of aesthetics and not merely of professional occasion.

3 Life at the palace at once removed him from the friction of professional intercourse. Velazquez could ignore the jealousies, quarrels and vexations involved in living among his colleagues.

4 The royal buildings of Philip IV contained one of the most important collections of paintings existing at that time. All his life, Velazquez had the history of European painting before his eyes and at his disposal. Every work of art has of course all past art as its natural subsoil. But the creative artist must absorb the past precisely in order to avoid it, to transcend it. An analysis of the work of Velazquez, this man who spent thirty-six years of his life immured in a marvellous museum, leaves us amazed at how very few were the influences which acted upon it. In their studies of painters, art historians talk about influences with surprising arbitrariness. If the reader wishes to observe the ingenuity with which art history tends to be written, he has only to consider the pictorial sources suggested for *The Surrender of Breda*. There is scarcely a picture in which a lance is raised on high that has not been considered as a precedent to that of Velazquez! Yet if one looks at those precursors with attention it will be seen that to have borrowed the 'lance' motif and to have given it the role it plays in *The Surrender of Breda* implies much greater skill than to have invented it *a nihilo*. These vices of the art historian hide the truly important lack of influences in Velazquez' works. What then has been his attitude to pictorial tradition? This question, as we shall presently see, will help to introduce us to the most profound and exciting aspects of Velazquez' oeuvre.

Let us now consider the negative effects that his premature entry into the palace produced in Velazquez' life. In a court like that of Philip IV, which was ready-made and not in a state of growth, everything was formalized and mechanical. Despite the fact that the king was a great amateur of the arts, nothing interesting ever happened in his circle.

The atmosphere of the palace was sterile. Life in the Alcazar of Madrid impoverished Velazquez' world, setting him apart from fecund experiences. Lope de Vega, who was a man of extraordinary vitality, felt for this reason a horror of court life. 'Palaces are sepulchres,' he said. And again: 'If they had feelings, I would even be sorry for the figures in the palace tapestries'. Imagine the effect of this paralysing atmosphere on an apathetic temperament like Velazquez'. The artist needs to feel the pressures of a hard life like a lemon needs to be squeezed to give juice. From the age of twenty-four, Velazquez had all his problems solved for him.

The urge to realize our vocation, to succeed in being what we are, is what nourishes our energies and keeps them taut. Velazquez' vocation was made up of two factors – the artistic aspiration and the aspiration to nobility – and both became satisfied without struggle, without contest, without hardships, without delay, almost imperceptibly, at the very threshold of his life. The consequence is that he lacked vital tension. Chance furthered his natural propensity to withdraw into himself, carrying it to extremes. For him, living became a matter of keeping himself aloof. His art is the confession, the expression of this radical attitude towards existence. It is the art of distance. Having dissociated painting from its context of gainful occupation, he could take his art at a distance and see it as a pure system of aesthetic problems demanding solution. For this reason, apart from the inevitable portraits of the royal family, Velazquez never repeats himself: each picture is a separate exercise, a unique statement. Furthermore, he withdraws from his own creations, leaving them almost always incomplete. They are wont to lack the 'final touch', the definitive stroke. Now we can also understand his unconcern about his fame. He keeps himself aloof. Not surprisingly, therefore, his pictorial style consists of painting things as seen from afar; in his pictures, for the first time and in radical form, painting abandons the tactile values, those values that, in the visual world represent how much there is in things that can be laid hold of, how much there is in man of the prehensile animal. His figures will be intangible, visual spectres. Hence, finally, the fact that Velazquez is the painter least concerned with the spectator. He does not confide in us at all, he 'tells us nothing'. He has painted the picture and gone away from it, leaving us alone before its surface. His genius is unconcerned with pleasing.

When, delighted by the unrivalled grace of Velazquez' mode of painting, where there is not a single brushstroke without its sharp intention, we are disturbed that he painted so few pictures and that of these a third consist of portraits of one and the same person, we cannot help imagining another life for Velazquez, such as it might have been had Philip III not died so soon. We would not wish to renounce the peculiar qualities

95

of his inspiration, this lyricism of distance and indifference to pleasing; on the contrary, we would like to see it applied to a wider repertoire of themes, and thus imagine Velazquez lost in the normal life of his craft, moving about the world, living in taverns and monasteries, vexed by economic necessity and the knavery of his colleagues, experiencing at every hour the erosions of contact with the harsh life of Spain. That is to say, we would like to see the spirit of distance holding fast in face of the invasion of things which encroach too much on a man's life, which chafe and gnaw and caress and impassion him. But pure chance decided that Velazquez should live all his life inside a glass enclosure.

Part III

During his youth in Seville, Velazquez painted *bodegones*. The subject of the *bodegón* is a kitchen or tavern scene, where there are plates, bottles, pitchers, vegetables, fish and a few human figures of the humblest social classes. Velazquez was doing nothing out of the ordinary when he began painting them, for all the young artists of his generation were doing the same. The *bodegón* can be most readily defined by what it is not: it is not a painting of a religious theme, nor a subject from mythology, neither is it what was then called a 'history' painting. In the *bodegón* there is no event or subject of any importance, nor is any rhythmic construction of forms to be looked for. It is really the painting of the commonplace. Italian art, that triumph of tradition, had been quite the opposite. It was the painting of the 'Beautiful'. One after another, the succeeding Italian schools continually extracted Beauty in every possible form from this source, painting turning more and more into wordless rhetoric. About 1550, the urge to produce *stupore* becomes dominant: the Beautiful becomes stupefying. We have arrived at the Baroque. In the paintings of Tintoretto and Rubens, we find the painting of pure movement, a dynamic frenzy. All this will be exaggerated by the Mannerists, and, *pour épater les bourgeois*, El Greco will perform feats of distortion before their eyes. But when this happens in art, it means that a cycle of artistic possibilities will eventually have been exhausted. The well of Beauty and formalism will have run dry. It was at this stage of artistic evolution that the young Velazquez found himself with brush in hand. He saw the situation with utmost clarity, and within himself must have exclaimed with irrevocable decision: 'Beauty is dead! Long live the rest!'

The question was to discover what was the rest. To paint *bodegones*, which today seems to us the most inoffensive of occupations, signified about 1615 a work of subversion and the height of insolence. Thirty years before, Michelangelo da Caravaggio, the son of a Lombard builder,

had performed the first revolutionary act against the traditions of both Italian and European painting. He had allowed the 'natural' element to enter his pictures – hence his art was called 'naturalism'. His pictures aroused horror, like the acts of a terrorist. Even in 1633, Carducho, the old Italian who was court painter at the time when Velazquez arrived in Madrid and who persecuted the latter as much as he could with his envy, was calling Caravaggio the 'anti-Christ'. The truth is that the Lombard painter conserved the essential quality of baroque painting, which was the determination to produce *stupore* and give an impression of *terribilità*. The innovation boiled down to the introduction of plebeian characters into his pictures and to changing the significance of the chiaroscuro. Till then, this had been an abstract element employed to indicate corporeal volume: the illumination – the light and shade – was conventional and arbitrary, as was the drawing, and therefore, like the latter, was a purely formal element. Caravaggio decided to copy a real illumination, albeit selecting artificially-contrived combinations of light: the light of a cave, in which one ray lights up violently a portion of the figure, leaving the rest in inky darkness. Thus it was an astounding, emotional and dramatic light, but ultimately a real light, a copied light. This was the light of the *bodegónes* that Velazquez painted in his adolescence.

His intention, however, was very different from Caravaggio's. Let us consider the famous *Corsican Water-carrier* which is in the Wellington Museum. First of all we note that the dramatic quality of the chiaroscuro is greatly toned down and is not, as in the works of the Lombard and all the *Tenebristi*, a real protagonist in the picture. In the youthful *bodegón* of Velazquez it no longer holds sway and is reduced to being merely the medium whereby objects make their appearance. These are the principal participants – the objects, persons and things – and not the composition, not the formal rhythm of lines, masses and empty spaces, the symmetries and patterns, the light and shade. In this picture, there are three figures, a pitcher, two glasses, and a vessel full of water. We are dealing with a collection of portraits. A painting is a portrait when it purports to transcribe the individuality of the object. It is a mistake to think one can only make a portrait of a man, or perhaps of an animal. Here we have, together with the portrait of the old water-carrier and the boy and the figure seen dimly in the darkness, the portrait of a pitcher, some glasses and a cup, which in consequence are converted into *this* particular pitcher, *these* glasses, *this* cup. The portrait, as I have said, aims to *individualize*. Of each object it makes a thing *unique*.

Velazquez, in fact, is a portraitist. Without further amplification, this frequently-made observation conceals rather than elucidates what there is of grandeur of design in the works of Velazquez. Not only because one can be a portraitist in many styles, so that this affirmation tells

nothing of what was peculiar to Velazquez, but because it presents us his art back to front. It is not a simple case of Velazquez painting portraits, but that he was to make of the portrait the radical principle of painting. This was a very significant and daring attitude, turning accepted painterly concepts on their heads. Bear in mind that up to the seventeenth century the portrait had not been considered as painting properly speaking. It was rather like a sideline of painting, something secondary and additional, of highly problematical aesthetic value, even opposed to art. For the art of painting consisted in painting the Beautiful, and, for that reason, in de-individualizing, in moving away from the world. A great portrait-painter was not considered as a great painter.

In every picture there is in fact a struggle between the 'artistic' forms and the 'natural' forms of the objects. One can almost speak of a general law in the evolution of every great artistic cycle, according to which, after a first stage in which this struggle is indecisive, the constructive forms begin to predominate over the forms of the object. The object is, in the last instance, respected, but its 'natural' forms are obliged to serve for the realization of 'artistic' forms. This is the moment of classicism. But soon the dominion of the formal begins to tyrannize over the object. Now starts the over-bidding of formalism, whose first manifestation is Mannerism. After this, the formalism of the lighting comes to subjugate, in its turn, the linear structure. Art can proceed no further in that direction, and the only thing which can save it is a revolutionary movement which makes the object and its own forms triumphant in the picture. This is what has been called 'realism' and this is what Velazquez represents. But to say his art is realistic is nothing but a more forceful way of saying nothing.

Art, clearly, is always a matter of conjuring with that reality which outside of art oppresses and vexes man to excess, transforming it by innumerable and even contradictory means. When Velazquez abandoned the formalist Beauty which till then had been the aim in painting and went directly to the object as it presents itself to us in its everyday aspect, humble and tragic at one and the same time, do not think he was renouncing the process of removing art from reality. That would have been the equivalent of renouncing art. But, prior to Velazquez, the illusion had been achieved by less difficult means, that is by painting things which were neither real nor pretended to be so. For Velazquez the question presented itself in *inverse* and much more hazardous terms: to contrive that reality itself, once transferred to the picture, without ceasing to be the stark reality that it is, should acquire the fascination of the unreal. Consider those queens and infantas, the Innocence X, the scene in *Las Meninas*, those young women bathed in light in the background of *The Spinners*. They are documentaries of extreme exactitude, of an

unsurpassable *verismo*, but at the same time they are creatures of phantasmagoria.

What is the magic by which Velazquez achieves this incredible metamorphosis whereby in spite of approaching reality more closely than any other painter he provides it with all the grace of unverisimilitude? Because this is his concern: to convert the everyday into permanent surprise. If we take a look at his oeuvre in chronological order, we immediately discover the method he employs. In effect, from that *Corsican Water-carrier* up to his final works – *The Spinners*, or the portrait of Queen Mariana of Austria – Velazquez' technique is a continuous progress in a negative skill: that of dispensing with more and more. In face of the entire past of European painting, he sets about eliminating the representation of solid volume, that is to say, removing every allusion to tactile data. But the objects of our real surroundings are tangible even more than visual things: they are bodies. Yet he takes this to the point where we feel that if we touched one of his objects it would offer no resistance to our hands, in fact, would be a phantom.

Thus we understand what otherwise would prove too paradoxical: that Velazquez' realism is but a variety of the un-realism essential to all great art. He paints nothing which is not ordinary, of the reality which fills our life; he is, for this reason, a realist. But of that reality he paints only certain elements: those strictly necessary for producing his phantom.

Nobody, in fact, has painted an object with a fewer number of brush-strokes. Velazquez is, then, an unrealist. Making the things which surround us into impalpable, incorporeal presences is no mean conjuring trick. In this Velazquez accomplishes one of the most splendid achievements in the history of painting: the retraction of painting into pure visuality. Painting thus succeeds in finding its proper place before the world, one which coincides with its own self. One understands why Velazquez has been called 'the painters' painter'.

Now we have learned not to employ the term 'realism' ingenuously, we can say what dimension of reality, among the many it possesses, Velazquez manages to isolate: it is reality in its immediate appearance. But one must understand this word in its full verbal significance; the appearance of a thing is its apparition, that moment of reality which consists in its direct presentation to us. Our subsequent dealings with it – looking round about it, touching it, etc. – make us forget the first instant in which it appeared. But if we try to isolate that moment, to accentuate it and transfer it to the canvas, – then men, landscapes, animals, pitchers, glasses, are converted into apparitions, into eternal *revenants*. Here we have the unique pathos in Velazquez' art. In the picture, suddenly a man or a pitcher 'appears' – the question as to what it may be is unimportant. The important thing aesthetically is that this act of appearance is forever

repeating itself, that the object is forever 'appearing', coming into existence.

Velazquez is completely the opposite of the romantic, the sentimentalist or the mystic. Nothing at all matters to him. He gives a few brushstrokes on the canvas and says to us: Good, *there* it is! and passes on without further commentary. Only one thing concerns him: that the things *are there*, that they loom up taking us by surprise, with a ghostly air, in that mysterious ambit, indifferent to good and evil, beauty and ugliness.

The 'naturalism' of Velazquez consists in his not wishing that things should be more than what they already are. From this springs his profound antipathy to Raphael. He finds it repugnant that man should seek to endow things with a perfection they do not possess. Those little extras, those corrections our imagination sheds upon them, appear to him as a lack of respect for the things, an act of childishness. To be an idealist is to deform reality according to our desire. In painting this leads to perfecting bodies by defining them with precision. But Velazquez discovers that, *in his reality*, bodies, in so far as they are visible, are imprecise – something of which Titian had already observed. The things in his reality are 'more or less', they are only approximately themselves, they are not defined in rigorous profile, they do not have unequivocal and polished surfaces, but float within a margin of imprecision which is their true presence. The precision of a thing is its legend. The most legendary thing man has invented is geometry.

It is always said that Velazquez painted the air, the atmosphere, and so on. I cannot agree. The airy effect of his figures is owed simply to this daring indecision of profile and surface in which he leaves them. To his contemporaries it seemed the painting was not 'finished', hence the fact that Velazquez was not popular in his day. He had made the most unpopular of discoveries: that reality differs from myth in that it is never completed.

This fundamental characteristic of Velazquez' painting only appears in full clarity when we contemplate his entire oeuvre. In general, the radical intentions of a painter only become evident when we bear in mind all his pictures, and let them pass through our memory almost with the speed of a film. Then we see which are his continuous and progressive traits, which are the radical ones. It is not enough, however, to observe all that a painter has done, but that his total production should reveal to us what he has not done; this, more than anything, makes evident to us the most intimate character of his artistic purpose. It surprises me greatly that his omissions have not been singled out as the most characteristic feature of Velazquez. If we fail to emphasize these omissions we cannot perceive what is supreme in his attitude to pictorial art and what sets him in a place apart among all other artists prior to the nineteenth century.

In the seventeenth century, painting consisted of making religious pictures and mythological pictures, all other subjects counting as mere curiosities. But Velazquez, scarcely had he left Seville, resolved not to paint religious pictures. If he had never wavered in this resolution we might have thought him incapable of painting such themes, but in fact when in Madrid Velazquez painted four pictures of this kind: the celebrated *Christ Crucified*, the *Coronation of the Virgin*, *Christ Bound to the Column*, and the *Temptation of St Thomas*. This extremely small number gives us clear indication that Velazquez declined to paint religious themes. This was certainly not because he was irreligious. He may have been lukewarm in matters of religion – like many of his time – but it would be going against history to suppose he refused to paint church pictures from motives of impiety.

About 1630, in Spain as in the rest of Europe, the most select groups of devotees of painting, from Philip iv onwards, were becoming tired of religious pictures. This weariness could only be answered by another theme: the 'mythologies', the name given to compositions with subjects taken from pagan religion. Mythology was thus a sort of para-religion for the use of poets, painters and sculptors, which had been revived by the Renaissance. The works of Rubens and later of Poussin demonstrate this appetite for ancient myths. What attitude would Velazquez adopt towards this demand for mythologies? We have seen that for Velazquez in contrast to the rest of the painters of that time, painting was not a profession but a system of aesthetic problems and inward necessities. Loosed from its occupational obligations, turned into pure substance, art was itself alone. Hence the wonderful puritanism of Velazquez, which is so evident throughout his entire work and which has never been noticed, perhaps because he was a man of few words and did not condescend to underline with theatrical gestures his profound and radical resolutions. This is what we discover when, after his refusal to paint pictures of saints, we confront him with the only other possible kind of picture: mythologies.

Velazquez paints mythologies. Among them are *The Drinkers*, a Bacchic scene; *The Forge of Vulcan; Mars; Aesop* and *Menippus*, two semi-mythological figures; *Mercury and Argos* and other pictures on a pagan theme now lost. To all these must be added his greatest work, *The Spinners* – which, I do not know why, has not always been recognized as a mythological painting although it seems to represent the Fates weaving with their threads the tapestry of each existence.* But these mythologies of Velazquez all have a curious aspect to which, whether they admit it or no, the art historians have not known how to react. They have been called tentatively parodies or jests. For Velazquez' contemporaries

* See Appendix, p. 135.

101

– painters and public alike – a mythological theme promised something out of this world. For Velazquez it is a motif which allows the grouping of figures in an intelligible scene. But he does not accompany the myth in its flight beyond this world. On the contrary; in front of any theme of this kind Velazquez asks himself what real situation, which might more or less take place here and now, corresponds to the ideal situation which is the mythological subject. Bacchus evokes any scene with drinkers, Vulcan means a forge, the Fates a tapestry workshop, Aesop and Menippus are the eternal ragged ones who pass before us, looking like beggars, scorning riches and vanities. This is to say that Velazquez seeks the root of every myth in what we might call its logarithm of reality, and that is what he paints. Thus it is no jest or parody, but the myth turned inside out; instead of letting it carry him off towards an imaginary world, he compels it to move back towards verisimilitude. In this manner the pagan fantasy stays captive within reality, like a bird in a cage. This explains a certain painful and equivocal impression these pictures produce in us. Myths being fantasy at liberty, he invites us to contemplate them reduced to captivity.

This surely is the reason why Velazquez did not care to paint religious pictures. If he had wished to employ the same formula he applied to the mythologies, the result would have been scandalous. One of the *bodegones* painted in his youth demonstrates the clear consciousness with which Velazquez confronted this question. The picture called *Christ in the House of Martha and Mary* represents a kitchen in which an old woman and a girl are busy preparing a meal. In the room there is no Christ, no Martha and no Mary, but up there, high on the wall, a picture is hanging, and it is in this inner picture that the figure of Jesus and the two holy women are given their unreal presence. In this manner Velazquez declares his disinclination for painting what, in his opinion, cannot be painted.

The constancy with which Velazquez holds to this view and the deep preoccupations which it reveals cannot be dismissed simply as peculiarities of style. It is more a matter of a new conception of painting, of the function which is the concern of painters. Of course, he never expressly put his pictorial *credo* into words. The art historian has to pursue other methods than the historian or the philosopher. He must speak to us of men who do not talk. To be a painter is to resolve to be dumb. When a painter sets about 'speaking', theorizing upon his art, what he communicates usually has scarcely anything to do with what he himself does. Before an oeuvre of such pronounced and permanent characteristics – some positive, others negative – as that of Velazquez, we are obliged to transpose into concepts the actions and omissions of the painter.

I will therefore venture to formulate Velazquez' profound attitude to pictorial art.

In order to obtain its emotive effects – what is wont to be called aesthetic emotion – painting had always been compelled to flee to another world far from this one in which human life actually happens and runs its course. Art was a dream, a delirium, fable or convention, a decoration of formal graces. Velazquez asks himself if it might not be possible to make art of this world, with life as it is; art, for that reason, totally distinct from traditional art, in a way its inversion. With radical and energetic determination, he cuts loose from that conventional and fantastic world. He vows not to depart from the actual surroundings in which he exists. All over Europe, for two centuries without interruption, there had been produced quantities of poetic painting, of formal beauty. Velazquez, in his secret soul, feels in face of all this what nobody had felt before, but which is the anticipation of the future: he feels satiated with beauty and poetry, and has an ardent longing for prose. Prose is the form of maturity which art reaches after long experiences of poetic play. It is not possible, thinks Velazquez, that prodigious skill in handling brushes can have no other end, no deeper or more *serious* purpose, than that of telling conventional tales or creating ornament. The imperative of seriousness is that which induces prose.

No artist among his contemporaries expressed such feelings, or at least not with any clarity. We must therefore envisage Velazquez as a man who, in dramatic solitude, maintains his art in face of and in opposition to all the values triumphant in his time, both in painting and in poetry. We could not wish for greater proof of this interpretation than that afforded by the inventory of Velazquez' library, recently published by Sánchez Cantón. For in this library, of considerable size for those days, there is no more than one book of verse, and that a book of no particular account. On the other hand, the remaining books are principally works of mathematical science, together with several volumes of natural science, geography and travel, and a few of history.

Now it will be understood why earlier I thought it appropriate to record that Descartes belongs to exactly the same generation as Velazquez. The disciplines in which the two were engaged could not have been further apart – they are almost the two opposite poles of culture. Nevertheless, I find an exemplary parallelism between these two men. Descartes, too, in his profound solitude, turned against the intellectual principles still in force in his time; that is to say, against all tradition – as much against the scholars as against the Greeks. To him also the traditional method of exercising thought was hieratic formalism, based on blind conventions, and incapable of integrating itself in the actual life of each man. It is essential that the individual construct for himself a system of convictions wrought with the evidence produced in his personal nature. For this it is necessary to purge thought of all that is not

103

a pure relation of ideas, ridding it of all the legends with which the senses overlay the truth. In this manner thought is brought to itself and converted into *raison*. Finally, we must not forget that Descartes was the initiator of the grand prose style which was to be employed in Europe from 1650 to the Romantic epoch.

Thus each of the two men exercised, in their opposite disciplines, the same conversion. Just as Descartes reduces thought to rationality, Velazquez reduces painting to visuality. Both focus the activity of culture upon immediate reality. Velazquez, perhaps the greatest connoisseur of the artistic past existing in his day, probably regarded its huge bulk with admiration, but as being on a par with, say, archaeology.

Until then, everyday reality had been distorted, exaggerated, brought to excess, dressed up, or supplanted. What should be done in the future? The very opposite: let it be, merely extract the picture from it. Hence one of the characteristics which immediately claim attention in Velazquez' pictures: what his contemporaries called the 'tranquillity' of his painting. Nothing disquiets us in his canvases, despite the fact that in some there are many figures, and in *The Surrender of Breda* a whole crowd of people, which at the hand of any other painter would give an impression of tumult. What is the cause of this surprising repose in the work of a painter belonging to the age of the baroque, which had brought the painting of restlessness up to the point of frenzy? Not only was the actual movement of bodies depicted, but this was employed to give the whole picture a formal movement, as if stirred by a swift fluid current, some abstract gale. Even the figures at rest were given forms which are in perpetual motion. The naked legs of the soldiers in the *Saint Maurice* of El Greco undulate like flames. An example which shows what I mean and which is the prototype of baroque mobility can be seen in Rubens' *Christ on the Cross*.

In contrast to all this is the tranquillity of Velazquez' work, the most surprising thing about which is that in his scenes the figures are not at rest, they too are in motion. In my opinion there are two principal causes for this feeling of repose. One is his gift for assuring that the things he paints, although in motion, should be at their ease. And this, in its turn, arises from his presenting them in their appropriate movements, in their customary attitudes. He not only respects the form the object possesses in its spontaneous appearance but also in its pose. The horse on the right in *The Surrender of Breda* moves, but in a manner so familiar that it equals repose.

But Velazquez does even more for his figures. Not only does he take from the things themselves – and not from his own fantasy – the position in which he presents them, but from among an object's gestures and movements he selects the one which reveals greatest ease. This quality

of grace of Velazquez' figures is their poetic element. But it is evident that this poetry, too, comes from reality and not from the formalism which is added to it by fantasy. It is precisely a class of poetry that before I have called prose. Spanish people of all walks of life have the gift of moving with grace and elegance; this is what gives that 'Spanish air' which northern people always discover in the figures of Velazquez and which is for them one of their greatest charms.

But there is another reason why Velazquez' paintings give us an impression of tranquillity, so unexpected in a painter of the baroque epoch. El Greco or the Carracci, Rubens or Poussin painted bodies in movement, these movements being informed by a vague and imprecise motivation, so that we could imagine the figures in other attitudes without changing the theme of the picture. The reason for this is that those painters wanted their pictures to show movement in general, and did not intend to portray a particular movement by individualizing it. But let us observe the great pictures of Velazquez. *The Drinkers* represents the instant where Bacchus crowns a drunken soldier; *The Forge of Vulcan*, the instant where Apollo enters the god's smithy and tells him bad news: *Joseph's Coat*, the instant where his brothers show Jacob his blood-stained garment, *The Surrender of Breda*, the instant where a defeated general surrenders the keys of the city to a conquering general and the latter rejects them; the equestrian portraits, the instant in which the horse leaps; *Las Meninas*, a precise instant in the painter's studio. If, after all, a scene is real it is necessarily composed of successive instants, in each of which the movements are distinct. They are instants which cannot be mingled, mutually exclusive according to the exigency of all real time. Other painters paint movements 'moving', while Velazquez paints movements in one single, arrested moment. In fact, the pictures of Velazquez have a certain photographic aspect: it is their supreme quality. In focusing the painting upon what is real, he arrives at the ultimate consequences. On the one hand, he paints all the figures in the picture as they appear from one viewpoint, without moving the eye, and this affords his canvases an incomparable spatial unity. But on the other hand, he portrays the happening as it is in a certain and determinate instant; this gives them a temporal unity so strict that it has been necessary to await the marvellous mechanical invention of instantaneous photography to arrive at anything similar, and, incidentally, to show us Velazquez' audacious intuition. Now we can well understand how he differed from the other baroque painters of movement. The latter painted movements appertaining to many instants which, for that very reason, were incapable of co-existing in one instant alone.

Painters, until Velazquez, had wished to flee the temporal and invent an alien world immune to time, peopled by creatures of eternity. He

attempts the contrary: he paints time itself, which is the instant, which is existence as it is condemned to be, to pass, to decay. That is the thing he eternalizes and that, according to him, is the mission of painting: to give eternity precisely to the instant – almost a blasphemy!

This for me is what is meant by making the portrait the principle of painting. This man portrays the man and the pitcher, he portrays the form, portrays the attitude, portrays the instant. And there, ultimately, is *Las Meninas*, where a portraitist is portraying the portrayal.

Goya
1950

Part I

The main part of this unfinished essay was published in 1950 – the 'fragments' in 1958, posthumously

We see something new – perhaps a painting. Seeing is not something we do, but something that happens to us. What we do next only comes after seeing and this first action of ours is of some interest. It consists in looking around in our social environment, in books or conversations, in the world about us – for certain words or ideas which will make clear what this new thing is. This demonstrates the remarkable fact that man's first impulse is hopeful, trusting that what he needs – in this case, an explanation – is to be found in this world.

Each time I have seen Goya's paintings, etching or drawings, this hopeful impulse has sent me searching the library shelves, convinced that many books must have been written on Goya. It has always caused me renewed surprise to find how very few there are. Moreover there is not a single attempt to understand him, to make him clear to us. If there is anyone who demands to be understood, to be explained and not merely seen, it is Goya – above all if one considers his work as a whole. One recognizes this at once, but what one understands is always, for one reason or another, an enigma.

It is clearly the task of art historians to discover the hidden unity that organically connects all the ingredients of Goya's oeuvre. They need to explain how the man and artist who painted, for example, the tapestry cartoon entitled *The Crockery-Seller*, which records the best of all possible worlds, can be the same man and the same artist who covered the walls of his own house with the terrible stains of the 'black paintings'. Anything that fails to do this is not only *not* talking about Goya, but is actually avoiding discussion about him.

There is no history without substantiated facts, but history does not consist of facts. Their principle function is, firstly, to compel us to imagine hypotheses which would explain them, for any fact on its own is equivocal; and, secondly, to confirm or invalidate those hypotheses.

So let us imagine the man Goya. Our point of departure must of course be the information we possess about him, but we must not limit ourselves to this. This information merely contains points of reference

107

around the imaginary figure of Goya. Obviously, this is fantasy: what else should it be? Science is fantasy: for what else is the mathematical point, the line, the surface or volume? Mathematical science is pure fantasy, an exact fantasy, and it is exact precisely because it is fantasy. In the sciences of reality, such as physics or history, fantasy is conditioned, limited and impregnated by data, but the doctrinal corpus which comprises these facts cannot but be a creation of fantasy. The historical novel, in which imaginary 'data' – concrete facts for which there is no documentation – are added to positive data, is rightly classed, disparagingly, 'mere fantasy'. But when I say it is essential to imagine the man Goya, this is not a case of fabricating concrete happenings in his life, but of envisaging possibilities. A man is, above all, a system of possibilities and impossibilities, and the historian's task is to determine what they are. After all, this merely involves carrying out in a reflective and disciplined manner what even the ordinary observer does spontaneously all the time.

Consider one of Goya's 'black paintings'. It did not come about by instant combustion. It is made up of brush strokes laid on by a man's hand, and that hand was governed by an intention. Each of those brush strokes was performed with an end in view; to understand them is to relate them to this purpose. Therefore, there is nothing else to do but discover Goya's intention. And indeed, such a painting cannot be seen without various hypotheses as to his purpose taking shape in the spectator's mind. Once we have seen the painting, if we are to understand Goya we must turn our back on it and set about analysing our theories.

The example of the 'black paintings' is extreme, but what it reveals in such excess is present in any other of his works: the fact that, to a greater or lesser degree, every painting is equivocal, as anything in the nature of 'expression' tends to be. Therefore we need to interpret it, eliminating all the apparent meanings save one, which will be the authentic meaning it had for the painter. In order to do this, we must decide on his intention, and as a painter's intention is nothing but an action of his life, we are inextricably caught up in the life style of the man himself. There is no escape. If we wish to understand the truth, the least brush stroke of a painting will make us rebound from the canvas, wall, panel or pigmented paper to the dynamic sphere of a man's existence. Only after perceiving this with a certain clarity can we come back and look at the picture with some likelihood of knowing what it has to 'say'. A painter's life is the grammar and dictionary which if we understand it, enables us to read his work unequivocally.

108

Part II

First of all, one must view the whole range of an artist's work. It is too soon to consider his productions one by one, to define the style and its origins and changes. First comes the very simple yet decisive matter of making an inventory of the themes which the artist has painted, and, more important still, *the themes he has not painted*. The artist is not personally responsible for the exclusion of many of these themes; he is a 'man of his time' and his time has bidden him leave them out. But of the group of themes presented by his period, each artist has to make a choice – accepting some, refusing others – and this demarcation line clearly indicates the first thing we need to know about an artist: how he regarded his profession, which for him was 'being a painter'.

It is not a case, I repeat, of describing the style of his paintings. A painter's style grows out of the way he perceives and accepts his occupation. Velazquez, for example, once past his adolescence, never considered his painting as a profession. For this reason he did not accept commissions nor paint the subjects which the professional artists of his time used to paint. Goya's case is diametrically opposite. He painted all the themes – divine, human, diabolical and fantastic. In the choice of themes he is characterized by not having excluded any – from the religious painting, the allegory and the large-scale decorative painting (such as his frescoes in San Antonio de la Florida) to the anecdotal engraving and the caricature. More than once I have wondered whether this universal, all-embracing character of Goya's work is not one of the causes which have paralysed all attempts to define his organic unity.

What does it signify, this unquenchable thirst with which Goya absorbs such a torrent of themes? Various things, it seems to me, the first being that Goya felt himself capable of everything – which is not to say that in fact he was. The vulgarity of nearly all his religious paintings, the dullness of his allegorical scenes, indicate that, for him, feeling capable of an undertaking did not involve being conscious of worthwhile ideas appropriate to its understanding nor a personal affinity with the theme. Of what did it consist, then, this feeling of universal capability? In my opinion, it cannot be detached from a virtue Goya possessed in high degree, to which he gave supreme importance and of which he was proud almost to the point of mania – the richness, almost without limits, of his skill as an artificer, and of his expertise in all the techniques of painting, engraving and drawing – in fact, his craftsmanship. All his life we see him preoccupied with acquiring and mastering every available means of expression in two-dimensional forms. In the application of these techniques, moreover, he displays a constant originality. His wall-paintings are carried out in a highly individual technique, combining

pure fresco and tempera; his engravings are a mixture of the techniques of etching, aquatint and burnishing. A few years after Senefelder invented lithography we find Goya, an old man, making lithographs. His pictures are painted with brushes of all sorts, with cane instruments of his own invention, with spatula, palette knife and sponge.

Hence arises the shrewd suspicion that Goya regarded his profession as a superior form of craftsmanship, looking upon himself solely as an artificer. To understand him we should put aside the idea of the 'artist' to which the romantic era has accustomed us. From the end of the seventeenth century, public esteem of the painter diminishes – I refer to Italy, which set the standard in all aspects of European art down to 1800. Salvatore Rosa (1615–1673) held a princely position in society, as Rubens had done, but from 1680 painters went down in the social hierarchy. Inescapably, this decline was accompanied by an impoverishment of the painter as a person, making him in effect a mere artisan, albeit an aristocrat among artisans, if you wish. With this went a growing lack of culture in the artist, and a mentality little removed from that of the manual worker. Goya's letters are the letters of a cabinet-maker.

The second point which the universality of Goya's subject matter reveals is the same thing in reverse. During the greater part of his life Goya had no direct and personal relation with his themes. The fact that in the second half of his life the most personal inspirations suddenly burst forth, with an almost maniacal insistence on subjects which no one had commissioned him to do and in which he took pleasure, is something which merely proves his earlier detachment. So much so that, if a philologist attempted a precise definition of what *capricho* – a word frequently recurring in his correspondence, in his captions, in documents referring to him – signified for Goya, he would discover that it meant all that a painter does on the margin of his profession. The value which Goya's *caprichos* have since acquired ought not to mislead us about his basic state of mind, what things – among them his profession – meant for him.

I do not know whether others have noted a curious and disturbing remoteness, present in Goya's attitude to his assignments, and manifest in the works themselves. It is a remoteness, both personal and artistic, from his theme (I do not say from the picture, but certainly from its theme). The objects he interprets – things or people – do not rouse in him any direct, immediate interest and not the slightest human warmth radiates in their direction. He has placed them in front of him and limited himself to interpreting them according to his manner, some with care, others with atrocious negligence. In the pictures he painted on his own impulse – madhouse scenes, processions of penitents, masquerades, beheadings, executions by firing squad, wrecks, panics – his interest is

110

oblique. He paints them precisely *because* they are humanly negative themes.

This lack of human sympathy for the beings he paints is precisely one of the causes of his style. It has been frequently noted that when people are introduced into his paintings, they are transformed into puppets, easily exchangeable one for another. The faces are not faces, they are masks. The same motive contributes to another peculiarity of his pictures, brilliantly commented on by Mayer: there is no one dominant figure. Everything in them is equalized and transformed into a mere part of the composition. In Goya, the protagonist is the picture itself.

With wearying reiteration people speak of Goya's impetuosity, of the human warmth of his painting, but I see nothing of this except in some exceptional places in his work. The unique brilliance of painted surfaces which Goya presents us, the radiance which turns them into jewels of light and colour, actually dazzling our eyes – these do not argue impetuosity or emotional ardour. A goldsmith has no need to be impassioned. As for the distortion of forms, the carelessness of texture, the singularity of brush strokes characteristic of his last period – these are features which, beginning in England, appeared all over Europe at that time. This loose style persisted throughout the nineteenth century.

The immense range of his themes does not, therefore, signify richness of inspiration or enthusiasm. On the contrary, it signifies that, like the other Spanish painters of his time, he settled to his task like any ordinary workman whose livelihood depends on the orders he receives. Nothing so hinders an understanding of Goya as to suppose him possessed of the idea that painting is a 'temperamental' activity. The interesting aspect of his artistic personality is seen in how, from time to time and at a late period, the everyday nature of his occupation undergoes strange eruptions of original fantasy – *caprichosidad* – as if at that moment there appeared what the following century was to call 'temperament'. In Goya suddenly, and for the first time in painting, romanticism makes its appearance, with its character of spasmodic outbursts, mingled with the mysterious and demoniacal powers man carries hidden within him. Goya's reputation, in its turn, is a creation of the romantic world.

Part III

Goya was born in the village of Fuendetodos – a village of Aragon, which makes it the quintessence of villages. He received no literary education whatever. He studied art in Saragossa, where he associated with others of similar origin. He had the rough, impulsive, 'elemental' character of his countrymen when they lack the curbs and inhibitions imposed by

111

'good education', but there is no excuse for inventing legends of reckless exploits around him. Like so many other young painters, he secured the means of going to Rome for a time. His first works in the churches of Saragossa reveal him as a competent craftsman, well-gifted, less well-trained, and with nothing to say. Artistically, he conformed to the manners of his time, which were rigid in the extreme and only began to be stirred into life by the boisterous influence of Tiepolo's art.*

It should be emphasized from the start that Goya's development was very slow. When he came to Madrid in 1775 and began designing cartoons for tapestries, he had as yet done nothing which even remotely resembles the Goya we know. The so-called 'black paintings'† and some of his series of engravings – the work of the last twenty years of his long life – have been given undue weight in the interpretation of his existence as a painter and a man. At the time of his arrival in Madrid and his setting to work for the Royal Tapestry Manufactory under the direction of Mengs, I see evidence of another, quite different temperament.

In the tapestry cartoons, the potential and real Goya begins to be revealed. This occurs just when, for the first time in his life, he finds himself subject to the pressures of an homogeneous atmosphere, of precisely defined features: the world of the court, of the palace itself. The tapestries are for royal palaces; the Manufactory belongs to the crown; instruction is given by the court painter. Yet the raw, rough lad of Fuendetodos and Saragossa immediately becomes acclimatized; moreover, in so doing, his most personal inspirations begin to flower. Fifteen years later, in 1790, he comes in frequent contact with aristocratic society, forming friendships with the great intellectuals of the time. This is another ambience distinct from palace life, disturbed by other currents – and invaded by the 'new ideas'. We then witness a new burgeoning in Goya: potentialities which have been lying dormant are called into action. Another fifteen years later, when the effects of the French Revolution make themselves felt in Spain, Goya finds himself in yet another ambience, and immediately reacts with fresh inspiration and insight. All this would lead us to imagine a man hypersensitive to his environment.

But if we say Goya emerges in the cartoons, it would be well to come to an agreement about what it is that emerges. Some of the themes of the tapestries are of popular or semi-popular Spanish scenes. Through an ignorance which is unpardonable it was supposed that the popular character of these subjects was due to Goya's own free choice. This assumption has triggered off the idea of Goya as an enthusiast for the popular and traditional way of life, consorting with the ruffians and low-life characters

* Tiepolo was in Madrid from 1762–1770.
† Goya's famous paintings with which he decorated the walls of the house to which he retired towards the end of his life.

of Madrid, with bullfighters and braggarts. Today we know that not only did the general proposal that he should portray popular customs come to Goya from his superiors, but also that many of the themes were suggested to him. When on rare occasions this is not the case, Goya takes good care to state in the invoice: 'It is my own invention'.

One has to set against the supposed popularism of Goya the following considerations. First: from the beginning of the eighteenth century, the palace painters, who were foreigners – Houasse, Paret, and the sons of Tiepolo* – constantly employed popular subjects. Second: this was happening throughout Europe at that time. Third: 'popularism' had been one of the great veins of artistic inspiration on the Continent since the last third of the sixteenth century. The painting of traditional customs had therefore no special signification in 1775. But the fourth argument is stronger still: in Spain during the eighteenth century, a most curious phenomenon occurred. Enthusiasm for the popular, not only in painting but in the manners of daily life, seized the upper classes. To the curiosity and philanthropic concern which sustained popularism everywhere, in Spain there was added a strong tendency towards 'plebeianism', a word with a strict significance in linguistics. Frequently, two forms of the same word or two words which mean the same thing appear, one of which is of cultured origin and the other formed by popular pronunciation and usage. The tendency of the community to prefer the popular to the erudite form is called in linguistics 'plebeianism' and is normal in all languages, enriching them and lending them vitality.

Let the reader now imagine this tendency extended from verbal forms to the costumes, dances, songs, gestures and amusements of the common people. We shall have moved beyond linguistics to the general history of the nation. And if, instead of the usual amount of plebeian imitation, we envisage an impassioned and exclusive enthusiasm, a veritable frenzy which makes it into nothing more nor less than the greatest source of energy in Spanish life in the second half of the eighteenth century, we shall have delineated that great event of Spanish history which I call 'plebeianism'. Elsewhere the normal course ran in a completely opposite direction: the lower classes admiringly contemplated the manners of life created by the aristocracy and endeavoured to imitate them. It is the inversion of this norm that has sustained Spanish life for many generations. The common people lived enthusiastically in their own style, aware of themselves and taking pleasure in their self-knowledge. For their part, the upper classes felt happy only when abandoning their own customs and saturating themselves in plebeianism. Let us define the three principal manifestations of this strange social phenomenon.

* Giandomenico, who returned to Italy on his father's death in 1770, and Lorenzo who stayed on in Madrid.

The first consists in the costumes and adornments of the people of Madrid and certain Andalusian capitals. Inseparably united with this goes the repertoire of attitudes and postures, the gestures, lines and flow of bodily movements, modes of pronunciation, turns of speech, and words.

Words cannot describe how low the Spanish aristocracy had fallen in the second half of the seventeenth century. 'There are no brains here,' declared the *Conde-Duque* in an official document, and the same was repeated by Philip IV when, on the dismissal of the former, he took the reins of government into his own hands. The Spanish nobility had lost all creative powers. They showed themselves incompetent not only in matters of politics, administration and war, but also incapable of renewing, or even graciously maintaining, the forms of this daily existence. They ceased, therefore, to exercise the principal function of every aristocracy, which is the setting of an example. In consequence the people felt forsaken, without models, help or discipline from their superiors. They then displayed yet again the extraordinary power possessed by the humblest classes of the Spanish people for living by and from themselves, feeding upon their own resources and inspiration. From 1670, the lives of the common Spanish people began to turn in on themselves. Instead of looking outside for their manners, little by little they developed and *stylized* their own traditional ways. From this widespread but quite spontaneous development there emerged the repertoire of postures and gestures of the Spanish people in the next two centuries. That repertoire has a character which I believe makes it unique: namely, while consisting, like all popular expressions, in natural and endemic attitudes and movements, these are at the same time stylized. Performing them is not only living, but living 'in style'. The Spanish people created as it were a second nature which was shaped by aesthetic qualities. And that repertoire of constantly-used lines and rhythms constituted a vocabulary, a precious substance from which the popular arts emerged. These represent therefore a second, deliberate stylization performed on top of the primary style of movement, gesticulation and conversation. Typical of this are the other two grand manifestations of the plebeian wave which almost completely inundated Spain about 1750. These are the two greatest artistic creations of the Spanish people in that century: the bullfight and the theatre.

The bullfight as we know it has scarcely anything to do with the ancient, traditional festivals in which the nobility took part. It is in just those last years of the seventeenth century when, according to my theory, the Spanish people had decided to live on their own resources, that we come across fairly frequent references to the *toreros*, a term applied to certain men of the plebeian class who, in somewhat unprofessional groups,

travelled through towns and villages. Their performance was not as yet the bullfight in the sense of a rigorously structured spectacle, subject to rules of art and aesthetic standards. The gestation was slow: it lasted half a century. We could say it was about 1740 when the fiesta took shape as a work of art. The effect it produced in Spain was devastating and addictive. Only a few years later, government ministers were perturbed by the frenzy the spectacle aroused in all social classes. Rich and poor, men and women, dedicated a large part of every day to getting ready for the *corrida*, attending it, and talking about the deeds of their heroes. It was a total obsession. And do not forget that the bullfight itself is only the outer and momentary appearance of a whole world that goes on behind the scenes, which includes everything from the pastures where the fighting bulls are bred to the wine-shops and taverns where bullfighters and *aficionados* forgather.

At that time, the theatre excited no less enthusiasm than did the bulls. Why is it not recognized as a fact of common knowledge that the years between 1760 and 1800 formed the epoch in which Spaniards most enjoyed the theatre? This was a period when the theatre gave pleasure to everyone, and when everyone was able to identify with it. Now at that date the dramatists were of as little account as the painters. The dearth of scientific, literary and plastic talent in Spain from 1680 is appalling, to the point where it constitutes a pathological phenomenon demanding elucidation. Plays of the old baroque theatre were being presented for the millionth time. But on top of these had been added a whole series of new theatrical genres – *sainetes* (one-act farces), *jácaras* (ballads and dances), *tonadillas* (musical interludes) – of plebeian origin and style, or, like the *zarzuela* (musical drama), of courtly origin but becoming daily more permeated with popular ideas. These new genres lacked literary merit; indeed, they did not pretend to any. How can it be explained that, nevertheless, the Spanish theatre was then experiencing what has been perhaps its finest period? Those who have a fixed and naïve idea of world theatrical history and, ignoring the facts, suppose that drama is primarily a literary art-form, blindly fail to recognize that, despite the lack of great dramatists, this was a culminating point in Spanish theatre. But when it is realized that the quality of every theatre resides principally in the actresses, actors and staging, and only secondarily and transitorily in the dramatists the matter becomes immediately plain. The period of Spanish theatre to which we are now referring is an extreme example, almost a caricature, of this fact. From beneath the archaic grime of baroque drama and alongside the handful of imbecile authors who cluttered up the theatre, there arose from 1760 to the beginnings of the nineteenth century an uninterrupted series of brilliant actresses and of outstandingly talented actors – all, with the rarest exceptions, of

115

plebeian birth. In particular the actresses, who as well as speaking their parts were also singers and dancers, must have possessed qualities amounting to genius. Their popularity knew no bounds. Everybody knew and talked about not only the excellence of the actresses' performance in the theatre but also the minutest details of their private life. For the personality of these magnificent creatures overflowed the stage and made itself felt in the streets, *paseos* and *fiestas* of Madrid. The most exalted noblemen adored them, duchesses sought their company, and every evening the populace came to blows defending the superiority of the actress each group idolized. On a lesser scale actors too received the same treatment.

As a result, authors began to make their characters fit the people who played the parts, and rather in the manner of Hollywood, gave them star-vehicles to shine in. This was the case with Ramón de la Cruz, who held sway in the theatre for twenty years. This dramatist, who composed innumerable *sainetes*, *zarzuelas*, *loas* (prologues), *tonadillas* and *jácaras*, and who also translated French and Italian tragedies is an example of the pitfalls which can mislead the historian. For his famous *sainetes* are almost completely insignificant, and, what is more, do not even pretend to be great dramatic works.

The example which the nobility failed to set radiated from the stage. 'Who can doubt,' says Samaniego, 'that to these models (of the theatre) is owed that deplorable habit of *majismo** that affects everyone up to the most illustrious members of the court . . . even down to their costumes and rascally manners?'

It has been necessary to spend a while delineating the special character of plebeianism which constituted the authentic 'collective soul' of Madrid at the time Goya arrived at that city and the court. We will now be able to consider who Goya is, in relation to the supposed traditionalism which has been put forward in attempts to interpret his life and attitudes, for what a man ultimately does, *vis-à-vis* the traditional systems of his environment, determines what he is. However, to reach an unequivocal answer to our inquiry, we must add a decisive clause to all that has been said. It is not merely that plebeian customs existed so that anyone with a particular interest could go and find them. Things were not like that.

Against a delightful background of tranquillity, this part of the Spanish eighteenth century was characterized by passion. Everything was lived with vehement intensity, with an almost maniacal enthusiasm. People were not content just to go to the bullfight or the theatre: they hardly talked about anything else for the rest of the day. Furthermore, they argued and quarrelled with one another, a sure sign that all this penetrated their lives right down to the layer where passions seethe.

* Members of the artisan class remarkable for their freedom in dress and manners.

When 'La Tirana' was brought from Barcelona, by official order, to work in the theatres of Madrid, her husband failed to send on her costumes and jewellery. In view of this, the Duchess of Alba, one of her partisans, provided clothes for the actress. The Duchess of Osuna, the Duchess' rival, immediately did the same for her favourite, Pepa Figueras, darling of the *sainetes*.

There was thus no avoiding it. Even if one disliked the popular way of life, its ingredients thrust their way into everyone's existence. All Spain was divided into two great parties: on the one hand the immense majority of the nation, enthusiasts for the Spanish customs in which they were immersed; on the other, a few groups, small in number but formed of men of higher calibre – certain noblemen, men of science, statesmen and administrators – who were educated in the French ideas and tastes which prevailed in Europe as a whole, and for whom the popular customs of Spain were ignoble. The clash between these two great factions was intense and harsh. In truth, there was right and wrong on both sides. The *illustrados* – the men of learning – fought against *majismo*, attempted to suppress the bullfights and at times succeeded, and fiercely attacked poor Don Ramón de la Cruz for his burlesques. Curiously enough, when the men of learning denounced plebeian fashions, their prose was saturated with the very idiom used by partisans of the popular in conversation, which shows how deeply and irresistibly plebeianism had penetrated.

All this was coming to a climax in 1775, the very year when the young Aragonese painter arrived in Madrid. How intense was its influence on Goya's life and work, from then until about 1790? From a letter of his of much later date, in which he speaks as a matter of course of going to the bulls that day, we may gather he must have attended the fiesta in the previous years neither more nor less frequently than anyone else in Madrid. (In a letter of 1778 to Zapater, who was a fan of the bullfighter Costillares, Goya declared himself in favour of Pedro Romero.) During all this period he did not paint a single bullfighter nor make any painting of bulls apart from the cartoon *La Novillada*, which does not refer to a formal *corrida*, but to an amateur baiting of young animals such as might take place in any village. The picture is purely decorative in intention, and if one wished to take it as evidence of his *afición* to bullfighting – since the central figure seems to be his self-portrait – all it would prove is that at this date Goya was ignorant of bullfighting matters. Neither is there evidence that he had any intercourse whatever with people of the stage. Toward the end of 1790 he sent his friend Zapater some popular Spanish songs. 'With what satisfaction you will hear them,' he writes to his friend. 'I haven't heard them yet and probably never will; I don't now go to the places where they are played because it has come into my

head I ought to maintain certain ideas and preserve a certain dignity which a man should possess, and with which, as you can believe, I am not very happy.'

These words seem to me the most important piece of information that Goya has left us about himself. Let us consider what they intend to convey, and what they unintentionally reveal. First of all, Goya takes it for granted he will give his friend Zapater, a typical provincial, real pleasure in sending him those verses, evidently recently issued and then in fashion. That is to say, in the provinces they tried to keep up with the *manolerías* (fashions of Madrid). The second point is that Goya, in the fifteen years he had already spent in Madrid, had heard, like everyone else, the songs sung in places frequented by the *majismo*. He cannot have been referring to the theatres, where in any case there would have been no reason for his not attending. This is the maximum evidence that can be put forward on behalf of his enthusiasm for the Spanish traditional way of life, and it is far too small. Other than this, nothing is known of Goya's supposedly reckless life, of which there is not the least trace, neither in anecdotes of any reliability nor in the whole of his future work. The third point is that Goya here testifies to a change that had taken place in himself and his manner of life, prior to that date, so that now Goya has 'certain ideas' and these ideas impose on him 'a certain dignity', and this dignity is something 'a man should possess'. What has happened to the man from Aragon, as he enters his fortieth year?

In effect, it is a matter of a conversion. I imagine these fifteen decisive years of Goya's life as forming the following pattern.

He settled in Madrid about 1775, at the age of twenty-nine. Up till then, his life in Saragossa and in Italy had been the most commonplace existence of someone working at his craft. In Italy he saw nothing more than any young painter of his day would have seen. There was no originality whatever about his contact with Italian art. The painting of *San Bernardino* for the church of San Francisco el Grande which dates from 1781, demonstrates with lamentable clarity how superficially he had viewed the artistic world of Rome. Thus he came to Madrid without any artistic ideas at all, without inspiration, to practice and live by his profession like any other craftsman. In Madrid he dragged out the most humdrum existence; he knew few people apart from professional colleagues, among whom none stood out either for his art or his personality. Until 1783, save for the frescoes of El Pilar and the *San Bernardino* painting, Goya seems to have been exclusively occupied in producing tapestry cartoons for the Royal Manufactory.* The great nobles at that time were having their portraits painted by Mengs or the Swedish painter Wertmüller, or other foreigners. Goya was attached to the lowliest fra-

* See Introduction, p. 10.

ternity of palace painters, and this was the sole point at which his life touched a higher social level. Contrary to what has been said, he had no friends in the bullfighting world and had no love affairs with any actresses. He was, in brief, an artisan fulfilling his daily task. All that concerned him was climbing the ladder of professional advancement, and he struggled to find a loophole which would allow him to filter through to the higher regions. In 1783 he managed, at last, to paint the portrait of Floridablanca. The high hopes aroused by this introduction to a minister reveal the need he felt for protection in all the preceding years. Floridablanca did not live up to those hopes, however, and proved remiss in patronage.

Nevertheless, the cartoons, albeit slowly, had been advancing his reputation. A notable interest was soon shown towards him by the most eminent architects: Sabatini, Villanueva, and Ventura Rodríguez. This last person afforded him the opportunity of painting the Infante Don Luis, and shortly afterwards he began painting portraits of various illustrious people, one of the first being Ventura Rodríguez himself. The portraits were to prove the favourable wind which would carry Goya out to the high seas. In 1786, he was appointed *pintor del rey*.

From then until 1790, Goya's social environment changed, and with it his whole being. He began to associate with the most influential men and women of the nobility, and at the same time with the writers and ministers adhering to the new 'Enlightenment'. Both groups came as a revelation to Goya. Up to then he had lived like almost all Spaniards, surrendering impulsively to the mood of the moment. Now he found before him creatures for whom living was the exact opposite, who interpreted existence as a demand for constant self-renewal, bridling their spontaneity, moulding themselves to fit some ideal paragon. This implied a constant vigilance on all impulsive actions and a critical watchfulness on everything that was customary, done merely out of habit. Those men of the Enlightenment – I repeat, some of them aristocrats, others intellectuals and statesmen – held to a rigorous doctrine. They confronted life with 'theories'. Goya heard their words. Uncultured and of slow mentality, he did not understand very well what he heard, but he seized upon something fundamental: that one must not abandon oneself to the spontaneous, either personal or collective; that one had to 'live out' one's theories.

It was the first educational impact which made itself felt on Goya. And at forty years old! This insistence on reflection and self-restraint was like a rebirth. What was near at hand, once its habitual spontaneity had been suspended, became distant and strange. *For that very reason, Goya then discovers, round about him, the particular mode of living that is essentially Spanish.* Then and not before does he begin to paint themes

which have been called essentially Spanish, precisely because he, whose Spanish awareness had always moved well below the normal level, had ceased to have a typically Spanish outlook.

We are in 1787. In the two preceding years Goya has entered the elegant world of the duchesses and the circumspect world of the enlightened. It is surprising and exciting to see how Goya, the Goya that Goya had to be, suddenly awakes at the simple contact with those worlds. which are characterized, like all aristocracy, by an avoidance of spontaneity and impetuousity. This is the attitude in which those two worlds coincide: in considering that the better life is always *other* than the primary and given one; that life *ought* to be constructive and that the status quo must not be accepted mindlessly. The two groups differ in the way they approach their environment. For the aristocracy the popular way of life is only one among many different life-styles. It amuses them to contemplate and even take part in it, momentarily sinking themselves in it precisely because it is different. The intelligentsia, though they could not help being touched at some point by that same affection for the popular mode, reject it as a whole. The traditional mode of living is bad, barbaric, formed haphazardly through the irrational course of history. It only exists, like everything which simply 'is there', in order to be reformed. Radical reformism is an uncomfortable attitude towards life which always begins with a negative.

Is it not this that Goya's words in his letter to Zapater signify? Goya is *reforming* his life. He has given up going to places where you can hear *tiranas* being sung because life should be *other* than what one likes. Existence must stem from certain ideas which restrain every impulsive movement, exposing it to question. This is a painful process: 'with which, as you can believe, I am not happy.' Goya will never again be content. Even if there had not fallen upon him, two years later, the terrible misfortune of temporary paralysis and permanent deafness, unease would have been the note of his existence, because henceforward irreconcilable forces were at war within him – the primitive temperament and confused mentality of the rustic in opposition to the *nisus*, the impulse towards the high and select.

The fact is that it is not until about 1790 – three or four years later, I suspect – that Goya begins painting such objects as bullfighters and actresses – something he had not done in the previous years, when he was supposed to be devoting himself to bullfighters and other popular diversions.

Goya paints only two bullfighters: Pedro and José Romero. The portrait of Costillares is of very doubtful attribution, and the age of the painting does not fit the age of the subject. From the dates when these three performers were making their circuit of bullfights and the date

which would correspond to the last, we have to set these portraits about 1790 at the earliest. (The portrait of Pedro Romero contrasts with the others in that it appears to have been done from memory.) Three years before, Goya had made the acquaintance of the Duchess of Osuna, who was a fan of Costillares. All Spanish life at that time was pure partisanship. In 1790 he must have got to know the dashing Duchess of Alba, who was José Romero's protectress.

In 1794 he painted the first of his only two portraits of actresses, the one of La Tirana. This eminent stage personality was a very close protegée of the Duchess of Alba and of the Enlightened group and was also the first Spanish actress to have been educated in the style of the French theatre. La Tirana did not perform in *sainetes* or *tonadillas*: she was a tragedienne. And indeed, Goya's painting shows us an austere, aquiline face, with those enormous eyebrows with which, for some unknown reason, Goya endowed many of his subjects, including even the angels in his frescoes in the church of San Antonio de la Florida.

The motivation which I have put forward for these portraits should not be interpreted trivially. Of least importance is that this bullfighter or that actress was under the protection of one or another duchess. To me it is an example of how Goya, from 1787, began to regard the national life from the viewpoint of the two new social strata he had entered and where he was to remain until his death. As that viewpoint is double and contradictory – a liking for the plebeian when contemplated from a superior position, and a rejection of it triggered off by the 'idea' – Goya's work in this area is ambivalent and equivocal. Often we do not know if he is exalting or condemning his subjects, if he is for or against them.

Thus Goya's late contact with the intellectual disciplines produced in him opposing effects. On the one hand, it divided his personality, forever torn between his affinity for the life of the people, which was his own from birth – and a confused awareness of the sublime, which lifted him out of his native spontaneity and pledged him to a different mode of life. This duality would never merge into one, for Goya would never adapt to either of the two worlds but live on in perpetual unease and insecurity. His deafness would carry all this to the borders of pathology, secluding him in a tormented solitude when his temperament cried out for the protection and stimulus of living in an atmosphere that he could respond to with the most personal elements of his being.

On the other hand, the vital shock caused by the change of environment had one remarkable result: in breaking loose from traditions, including the pictorial ones which had held him fast, in proposing to reject first impulses and withdraw to the more profound and reflective depths of his nature, Goya's creativity was both stimulated and liberated. It is astonishing the chronological coincidence – which all historians have

noted – between this change in social relations and the appearance of the grand Goyaesque manner of painting, which would consist in a successive and progressive series of innovations and audacities, until it arrived at the frontiers of art, passed beyond them, and lost itself in mania and sheer arbitrariness.

Part IV

Anyone attempting to discuss something of the reality that was Goya finds himself plunged in the unreal atmosphere of his legend. This Goyaesque legend is one of the most curious phenomenon of the contemporary collective mind and so deserves attention. But unless we first dispel the traditional image of Goya which to a certain extent still persists, his legendary persona will appear at every turn in this study of the man and his work, disturbing and confusing our perspectives.

When, a few years after his death, a retrospective interest in Goya's paintings and engravings appeared for the first time, authentic information about him was already extremely scarce. Surprising it might be, yet this is a recognized norm in Spain. The Spaniard is not interested in what is close at hand. So, of the recently dead Goya, hardly anything was known. But his work, being as evocative as it was strange, seemed to demand some knowledge of the life and figure of the man behind it. This meant that facts would have to be invented. For this reason his biographies up to the beginning of this century are, with few exceptions, an example of contemporary mythology, and at the same time proof that man's capacity to create myths still flourishes. The biographies consist simply in confusing Goya with the people in his paintings, portraits and drawings. His life was thus turned into a mere duplicate of his creations, and when this was not possible because the subject was a woman, they take the next step and give Goya a mistress.

For some time now research has been demolishing this mythical biography piece by piece, but the legend is so tenacious that often the very men occupied in tearing down its main structure have themselves got caught up in some other corner of the imaginary and romantic edifice. Much would be gained if someone were to study in detail the origins of the Goya legend. It is not merely a question of correcting certain errors; the Goya legend contains not a single certain fact about his existence on which to build. I think it is essential to lift Goya's life and character out of this ridiculous quagmire in which they have always been stuck.

From his twenty-fifth year until his death at eighty-two, which deserves to be called his entire life, Goya did not find the least occasion to

demonstrate those propensities that tradition attributes to his youth – and we must take into consideration that he was living through the most chaotic and restless period of Spanish history. The perpetuation of the image of a Goya who was turbulent, quarrelsome, a womaniser who was incapable of compromise, is truly scandalous. If it were merely a case of exaggeration or understatement, if the adventures and gallantries attributed to Goya had even vague foundations one could proceed, without needing to warn the trusting reader. But as this is not so, it is necessary to review the known facts.

Therefore, it must be said:

1 Not one of the exploits, disturbances, and habits which are usually attributed to Goya has the slightest foundation in fact.

2 Almost the whole of Goya's life as we know it is incompatible with his legendary characteristics.

This wide abyss between the Goya legend and his known conduct was what we had to make clear: now we may ask ourselves when this false image of Goya began to take shape. And we are at once astonished by the lack of written references to Goya during his lifetime. Perhaps the greatest number occur in the letters of Queen Maria Luisa to Godoy, but they all allude exclusively to her poses for the portraits Goya was making of her. After the queen, it is in Jovellanos and Moratín where we find him most frequently mentioned, but altogether there are only five or six places where they each name him.

Goya became acquainted with Jovellanos at the latest in 1781, when they both entered the Academia de San Fernando. It is clear, for example, that Goya was present at the meeting of 17 July of that year, at which Jovellanos read his *Elogio de las Bellas Artes* (Eulogy of the Fine Arts). Jovellanos was only two years younger than Goya. They must soon have become close friends, and this no doubt contributed to Goya's commission in 1784 for the four paintings for the chapel of the Calatrava Order in Salamanca. This friendship with Jovellanos, which lasted up to the latter's death, does not support the notion that Goya was leading a disorderly life. It is strange, nevertheless, that Jovellanos, the man who best understood Spanish painting, should not have spoken of Goya's art. He uses only two adjectives in reference to him, in a passage which, since I have not seen it previously quoted, I shall copy here. In 1785, in the Sociedad Económica de Madrid, he read a paper in praise of Don Ventura Rodríguez, recently deceased, and some time after 1789 (the year when Goya was appointed *Pintor de Cámara*) and before 1799, he published the discourse with the addition of a few notes. In the sixteenth of these, speaking of the friendship and high esteem in which the Infante Don Luis had held Don Ventura Rodríguez, he says: 'The better to show his appreciation, his Highness ordered a portrait to be made of Rodrí-

guez, indicating that he wished always to have him in sight, and he entrusted this commission to the *skilful and vigorous* brush of Don Francisco Goya, *Pintor de Cámara* to his majesty and one of the artisans to whom he also showed his august protection. This portrait exists today in the possession of the widow of the good prince, whose name gratitude has already placed in the lists of the protectors of artists and the arts.'

Jovellanos might appreciate Goya as a portrait painter, but certainly he does not appear to have appreciated the rest of his art. The proof is that in the rough draft of an article he was preparing he insinuates that in Spain there are neither good nor middling painters. But the fact is that his active friendship continued to the end. Thus, in his letters to Fray Manuel Bayeu, Goya's brother-in-law, we read in a postscript: 'Since you say nothing of Señor Goya, we doubt whether he has made the journey to Saragossa; but if he has, do not forget to embrace him in the name of this person (Jovellanos), who ever holds the tenderest friendship for him.' In another letter he asks the painter monk for answers to a series of questions that Ceán Bermúdez was sending to painters in order to complete his *Diccionario*. On the basis of these replies, Jovellanos would send 'a report to be forwarded to the chronicler of the Spanish artists, who was a great friend of Don Francisco (Bayeu) and also of Goya and his wife.' With this and the notice in his diary of the 23 November, 1793, saying that Goya had suffered an apoplectic stroke and could not write, we have all that Jovellanos' texts tell us of the life of our painter.

Part V

Goya begins to exist for us when, in 1775, he arrives in Madrid and settles there. The group of painters with whom he had associated in Saragossa was already established in Madrid. Among them was Francisco Bayeu, twelve years his senior and further up the ladder of his profession, a man who must have possessed a sense of diplomacy, a capacity for leadership and a fertile wit, for which reason Mengs, then leader of the Spanish art world, had made him his aide-de-camp. Bayeu used to come and go between Madrid and Saragossa. Goya at that time was moving in Bayeu's orbit, and many young Aragonese frequently came to Madrid to seek the favour of their countryman, the Count of Aranda, who was then enjoying great power. Goya, after painting the frescoes of El Pilar, passed more than three years in Saragossa with little encouragement; the time had come to set out for the wider world. Besides, he felt himself strangely wearied of his countrymen. He did not quite

know why, but for him the atmosphere of Saragossa had lost its savour, it now irritated and asphyxiated him. Who is this man called Francisco Goya whom we find in 1775, at the Spanish court?

If we follow the traditional historical examples, we shall answer more or less as follows.

Goya was twenty-nine. Born in Fuendetodos, he was three when his parents moved to Saragossa. It was not really a labourer's home, as has often been said. They probably had some land and a house and certainly they had one in Saragossa, since it is recorded that in 1760 they sold it. In the city, Goya's father worked as a gilder, a trade in which the artisan rubs shoulders with the artist. Goya took his elementary studies in the Escuelas Pias. When they were summarily concluded, he entered the Academy of drawing and painting of Don José Luzán, who had worked in Naples and knew the topical themes of Italian art, though his work was mediocre. Goya's life in these years is completely unknown. All we can legitimately infer is that he must have known the painters, led by Francisco Bayeu, who later transferred to Madrid. And in fact, in 1775, Goya himself goes there.

All these facts are important, and we shall need to refer to each of them in its time. But what they fail to do is answer our previous question: who is this man called Francisco Goya who arrived in Madrid in 1775?

Part VI

In face of the legendary Goya we seek the authentic Goya, and this means we must find out who Goya was to himself – for that is the only reality. But is it possible to discover this? The *I* is an entity so secret, so hidden, that often his own identity is not evident even to the man himself.

So, we find the man called Goya finally installed in Madrid at the beginning of 1775. Who is he? Goya is a painter. By this I do not mean that Goya was Goya and that furthermore he painted. I mean exactly the opposite: that fundamentally Goya was to himself nothing but a painter, that painting was his very substance, that as far as he was concerned, painting and living were synonymous. Perhaps this did not make him any different from the other men living in Madrid who had the vocation of painting. Because this is what it is about: a vocation. The *I* of a man is his vocation, which coincides sometimes more, sometimes less, sometimes not at all, with his actual trade or profession.

When Goya arrived in Madrid his vocation coincided completely with the profession of painting. The same could not be said of Velazquez, and for him it is more questionable to affirm that he is a painter as roundly as we can say this of Goya. We are not very familiar with the

lives of the other Spanish painters who were his contemporaries, but it is doubtful whether any of them acknowledged a vocation so resolute, and so totally at one with his whole personality. One could say that Goya did not have the vocation, but rather that the vocation had him, possessing him completely. We shall see presently in what precise sense we must consider him as one truly 'possessed', taken over by the demon of his own inspiration. There has never been a man more dedicated to the easel, to the wall, the paper, the copper-plate, the lithographic stone. For this reason his production is exuberant, among the most abundant recorded in the history of painting. One day, when historical research is made with more accuracy, someone will work out statistically the hours Goya must have spent painting, drawing, and engraving. It will then be interesting to see how many hours this left him free to devote himself to other aspects of life.

We are trying so far as possible to establish the meaning of the word 'Goya', so that there will be nothing equivocal about speaking of this man, and particularly of his art. But for the true and most authentic meaning of this word we must try to see Goya from inside Goya. This viewpoint is here being employed for the first time, and it is an inverse viewpoint to the usual one, since in it one adopts, as the contemplator's point of view, the point of view of the contemplated. The unfamiliarity of this demands a certain effort on the part of both the reader and the writer: it obliges both to keep looking at things inside out. Biography, treated in this manner, may lose the pleasant, fluid appearance of narration and take on a quite complicated analytical appearance, converting itself into the algebra of a human life. On the other hand, making a biography difficult makes it resemble life a little more.

Part VII

Now we must find out what this provincial lad who enters Madrid by the Puerta de Alcalá at the beginning of 1775 was like. I have already said he was a painter by profession. One must understand that his whole person fitted the general pattern of the profession as it was then understood, and this not only as regards being an artist, but in all aspects of life. He was a typical representative of the provincial middle-class which, in Spain at that time, was extremely rough in manners and taste, without culture and of a very limited outlook. As an artist and a man, he was shaped by the traditions of the times or – and it amounts to the same thing – he felt himself one with the society around him, dependent upon and nourished by it.

Nevertheless, Goya was already Spain's first painter. This is what is

not readily appreciated, and demands explanation. But it is essential to try to make this clear for in it lies the key to understanding Goya in these first years in Madrid.

Thus there is no need to think that any powerful person pulled strings to obtain for the young Goya such an important commission as the fresco of the Coreto. On the other hand, the Chapter* would not have risked a failure. The choice of the as yet green young artist can only be explained if some highly influential recommendation had been made on his behalf. In the Acts of the *Junta de la Fábrica* we learn of the hesitations about whether or not the arguments in his favour, made in private, were of sufficient weight. Goya is required to present the customary sketches, and they would have to be submitted to the Royal Academy for approval. This was on 11 November. But on 27 January of the following year – 1772 – the Council declares: 'Goya presented his sketch for the painting that is to be in the vault of the Coreto, *the gentlemen having already been informed as to its being a piece of talent and especial taste*; it was approved by the Council and, despite the earlier resolution of the Council to present it to the Royal Academy for their approval, they were of the opinion that the work should begin at once.' Thus there is 'information' which reassures the Chapter and persuades them that further negotiations are unnecessary. Now this highly efficacious 'information', this recommendation, could only have come from Francisco Bayeu, who was already the most eminent painter among the Aragonese. Bayeu's artistic status had already been established in Madrid: Bayeu *was* Mengs and the Royal Academy. If he did not have a hand in the affair, it would not be clear why the commission did not go either to Francisco Bayeu himself or to his brother Ramón. This could be related to the fact that around this same date Goya officially declared himself a pupil of Bayeu.

Once he had been chosen for such important and distinguished work, one understands the other two large commissions Goya received in the three following years, from 1772 to 1775: the mural paintings for the Carthusian Monastery of Aula Dei and for the oratory of the counts of Sobradiel. I doubt whether there were other commissions of equal importance in Saragossa in these years, and it is significant that such as there were were all for Goya. But Goya knew very well he received them as the pupil and friend of the Bayeu brothers. He accepted this fact with good will, and at that time did not aspire to anything else.

These paintings with which, for us at least, Goya commences his career, are a mere job of work. They are so, in the first place, because of their subject matter. At that time, a 'painter' was primarily one who composed pictures on religious subjects. Therefore Goya, who begins in this way, will not consider his ambitions achieved until, thirteen

* The work was commissioned by the Chapter of the Chapel of El Pilar in Saragossa.

years later, he finds he has gained a definitive victory over the other painters with his painting of *San Bernardino* in the competition to decorate San Francisco el Grande. This is one reason for counting the decade from 1775 to 1785 as a separate epoch in Goya's life. For Goya came to Madrid in the first of those years to carry out what he achieved only in the last.

But those frescoes and murals are also mere jobs of work both in their idea and execution. When we look at them today, knowing as we do his later work, we find here and there, like lightning flashes, glimpses of colour, line and attitudes that seem clearly Goyaesque in manner. But they do not constitute the work; rather they are escapes or flights of fancy that run counter to it, and which for his first spectators were incomprehensible or might even put them off the work as a whole. The entire work, created from traditional subject matter, was made of things that were learned, and this is what I understand by a mere job of work. But one must add something more: even considered as what they are – productions of common workmanship – this workmanship is not particularly good. Thus we already meet, at this first step, something that will accompany us in all our studies of Goya, and which is extremely complex to express – namely, that although at the root of his personality lies the conviction that he is a painter, Goya is not a good workman. The fact that he delights us with his genius is abundant compensation for his deficiencies, but should not make us disregard them. And this not from an implacable sense of justice, which would be a sterile and inappropriate pursuit, but because otherwise we shall not properly understand Goya. This man is a crippled genius who succeeds in making the most agile leaps towards the summit of art; we shall see, furthermore, how the peculiar delight his art produces consists ultimately in that contradiction. I cannot easily imagine anyone speaking of Goya without bearing both aspects of his work in mind, because in him the errors, omissions and deficiencies are no less a part of his artistic being than his greatest perfections. The carelessness of Goya, painter by trade, is an inseparable component of the excellence of Goya, painter of genius. Anyone who fails to recognize this has neither learned to listen truthfully to what goes on in his own mind when faced with Goya's work nor is he capable of showing us the elements which make up this artist's art.

Those three big commissions, together with a few lesser works in the churches of neighbouring villages, were tasks quite large enough to have occupied Goya's time during those three years. He could not have painted much more. Yet he was then in the prime of his youth, and there would have been no more fitting time in all his career for indulging in those adventures and brawls that legend attributes to him. And indeed various anecdotes referring to this stage of his life are in circulation, the

last of which consists in nothing less than that he had to move to Madrid in 1775 because he had killed a man. It is interesting to note the style of nearly all the anecdotes attached to Goya's life. The act they describe is always tremendous, but the protagonist has no recognizable form, lacking every detail of reality. Thus he stormed a convent in Rome to abduct a nun, or he killed a man – just like that, without further details. Goya's supposed escapades are always composed of abstract adventures. On the rare occasions when the anecdote is precise, it is exploded by exaggeration of detail.

From 1775 we have Goya's life under our inspection, and are able to confirm that in all of it there is not a single event which suggests the slightest trace of recklessness. If there is anything extraordinary about Goya's life it is that it was extremely humdrum. Nor is there any doubt about the temperance of Goya's existence from the autumn of 1771, when he returned from Italy, and the spring of 1775, when he moved to Madrid. A minor reason is the improbability that a man employed for the greater part of the time in various churches and a Carthusian monastery would dedicate his few free hours to reckless debauchery. The decisive reason, however, is that Goya's personal life during this phase is marked by these two acts: his declaration, at its commencement, in 1771, of his being Bayeu's pupil, and his marriage, in 1773, to Josefa Bayeu. This means he had passed those years in the bosom of that family. Now Francisco Bayeu – it is enough to see his face in the two portraits Goya made of him – was a man who knew no other existance but one of great strictness; furthermore, he was painfully scrupulous in his conduct and, delighting to direct and rule, watched with a somewhat heavy hand over the life of his relations and friends. Even in 1786 Goya was trembling lest his brother-in-law should find out too soon that he had bought a big carriage and a pair of mules. His two other important friendships in Saragossa, with Don Juan Martín de Goicoechea and Don Martín Zapater, underline the 'formality' of his environment. To think that, while diligently moving within these narrow confines, Goya would go roistering and brawling through the streets of Saragossa, seems too incongruous.

He must have completed the decorations of Aula Dei, collected his fee, and, with what little money he had saved during the previous three years, was able at the beginning of the next year to get married, make the journey to Madrid, and confront life at the Court. The reason for this move is quite clear. Mengs, artistic director of the Royal Manufactory, had convinced the senior administrators at the Palace that new painters should be commissioned to design the tapestry cartoons, with a small salary – 8,000 *reales* – plus the value of each work. Bayeu informed Goya of this and advised him to go to Madrid and take advantage of this ex-

cellent opportunity. And in fact, on 18 July 1775, together with Ramón Bayeu and Manuel Napoli, Goya was presented to Mengs.

This then is the man who enters Madrid by the Puerta de Alcalá – not a fugitive from justice, but a man on his honeymoon with his wife at his side.

The paradoxical thing is that this new arrival, twenty-nine years old, was already Spain's foremost painter. Yet it is now clear that Goya had rather more failures than triumphs behind him, that the flattering commissions he had received in Saragossa would have counted for less than did the recommendation of his brother-in-law, and that other painters of his age were ahead of him in the profession. It is therefore evident that judging him the foremost painter of Spain does not mean he believed that others would see him as such, nor that they actually did so. Nor does it mean that in his own opinion Goya felt himself to be Spain's first painter. At that moment he did not remotely imagine that he had achieved anything whatever which might raise him above his contemporaries. He was well aware of being no more than one of the more promising of the young painters, a young 'hopeful'. Thus we see him in those first years in Madrid working docilely, well content under the direction of Francisco Bayeu. Even in 1779 he would make it clear – without any need – that a painting executed by him was Bayeu's 'invention'. It would not have been otherwise, for in those days he did not possess any special ideas that were new either in theme or style.

However, we have seen that the *I* of a man belongs to the future, and it is from thence that he confronts the present. In that future, Goya sees his future work and feels with great conviction that its qualities are so superior to those of his contemporaries that there is no room for the slightest doubt that he will be the foremost painter of Spain.

Goya, for various reasons I shall state, is an extreme example of the vital situation which comprises the 'creative man'. It is therefore worthwhile clarifying this important human phenomenon.

Here we have, on the one hand, Goya with no fixed project of an innovative character as to what he is going to do in painting; on the other, Goya, living in anticipation of his own future *seeing with invincible clarity* that this future work of his is superior to all that the others are now doing.

Have you ever thought about the strange situation of the creative man prior to the act of creation? We see the artist's excellent work, and it is obvious that before being there in its finished and perfected state, it was only an image or idea in his mind. But the idea or image in the artist's mind is, at least in its principal components, the same as the work, save that it is in the mind and not on the canvas. What is essential to the

creation already exists in the idea or image of the work. The rest is execution, something very important and requiring new capabilities, but which nevertheless is not the creative moment proper. Therefore, the interesting point is to ask oneself what form the seeds of creativity took *before* the image or idea took shape: what we might call the 'situation of the creator prior to creating'.

Goya is an extreme example of what we can call the 'creative man'. We resort to the term 'creation' when we find a man creating forms which are new – in art, in thought, or in conduct. What is created will have greater significance according to its newness; that is according to how original, how unprecedented, it is. In this sense, the innovating components found in Goya's work are probably the most numerous in the history of art.

However, Goya's innovations do not make their appearance all at once, but emerge gradually and with exceptional slowness. The majority of artists reach the full authenticity of their style fairly early, and the impetus of this achievement, apart from slight modifications, carries them along for the rest of their lives. In Goya, by contrast, we witness a continuous series of partial flashes of illumination, which never quite succeed in coming together to produce a complete unity of style but which nevertheless continue without interruption from the age of thirty until his death at the age of eighty-two. In him, the strictly creative situation is prolonged with abnormal persistence. Both these factors – his innovating power and the slowness of that innovation – make him an exceptional example of the condition we are attempting to explain – if this is at all possible – the condition of genius.

Fragments*

Goya's work for the Tapestry Manufactory went on for sixteen years, from 1775 to 1791. At the end of this period he had modified his style, but his personality and life had also undergone a radical change. If we wish to understand this change we shall need an idea of what Goya was like in the preceding period, that is, during the years he was engaged in making tapestry cartoons. But it happens that we have even less information about these years than of those that followed. He lived buried in the dark, invisible recesses of the city. From 1775 to 1783 we know of no work of his, apart from the tapestries, other than the religious paintings of El Pilar and San Francisco, but these are mere rhetoric and tell us

* The following additional remarks on Goya have been gathered together from various late essays on art by Ortega.

nothing of their author. In 1783 he made the portrait of Floridablanca; here Goya has introduced himself into the picture and this concerns us greatly. We see how he saw himself at that date. He is an artisan respectfully showing a canvas to a powerful and illustrious personage. From the letters to Zapater we know this is Goya's first contact with a higher level of society, from which he hopes for advancement in his career, nothing more. In 1784 he does the portraits of the Infante Don Luis and his family.

Let us consider a portrait by Mengs, and ask ourselves what the painter has set out to do with the person it portrays. Leaving aside the cold and leaden colouring, let us pay attention to the forms. At once we see that the artist has sought to transform the real figure into an object endowed with 'ideal' qualities. What, for example, is the ideal of a surface? Evidently, it is polished, like burnished metal or finely glazed pottery. Mengs gives all his figures this 'ideal' gloss, both in their garments and their flesh. Another quality of things that real vision never fully allows us is their volume, their corporeal solidity. Volume is always a transposition of the tangible to the visible. Mengs always succeeds in giving his figures a perfect rotundity, where each point occupies its unequivocal place to signify the third dimension, bulk and depth. The Italian style of painting had always consisted in painting the 'beautiful', that is, idealized corporeal forms. Initiated at the time when Graeco-Roman statues began to be excavated, painting always considered sculpture as its ideal and tried to suggest tactile experiences on the visual plane. Bearing this in mind, we can define the radical change Goya's art experienced about the year 1790.

If we compare his portrait of Floridablanca – in 1783 – with any of the fine portraits Goya painted during the last years of the eighteenth century – for example, that of the Marquesa de Espeja or the Marquesa de la Solana, or of the tenor Mocarte – what is the principal difference we notice? In the first, chiaroscuro continues to emphasize volume, and we see Goya completely subject to the established modes of painting at that time. It is just one more sad academic attempt at galvanizing the old Italian tradition of art.

But the portraits painted after 1790 are of a completely different kind. The painting has ceased to be voluminous and has been made 'flat' – an expression I use only insofar as it signifies avoidance of volume. Far from trying to convey the third dimension, solidity is virtually a mere ironic allusion. If his earlier portraits were trying to give the illusion of three dimensions in two, here the opposite effect is obtained: the absorption of the third dimension in the other two, supplanting it by means of the values of the plane surface.

Unlike Mengs, Goya does not pretend to present the object in its totality: we find it as we see it at the first instance of vision, suddenly and still imprecisely. He tends to give us what there is of the real figure in the moment it appears to us. In this sense, he paints 'apparitions', illusions. Now this is what Velázquez finally achieved in his evolution. For this reason his painting is more purely painting than that of the others working under the influence of sculpture. I wonder whether, when Goya acknowledges the decisive influence Velázquez had on him, he is not referring to this radical interpretation of painting, this rendering of the plane aspect, rather than to any other partial and secondary influences.

Goya's original themes do not emerge until the first half of his long life is passed, about the year 1793. This fact is of the greatest importance. His biographers have laid undue emphasis on the latest aspects of his work, which are those held in the highest esteem and regarded as his greatest eccentricities, as if, inverting the natural course of time, the influences of his old age flowed backwards to his youth. Today we know that all the phantasmagoria associated with the *Quinta del Sordo* (The House of the Deaf Man) has to be fitted into little more than three years – from the later part of 1820 to the middle of 1824, when he moved to France – and the black paintings can then be seen as the work of a decrepit old man, scarcely able to see. . . .

When I read in Mayer's book (*Francisco de Goya*, Barcelona, 1925) that 'the intellectual level and high intelligence of Goya must be considered formidable', I waver between thinking that the expression is too vague, capable of many interpretations and committed to none, or that, taken at face value, it is not only untrue but completely blocks understanding of a reality as strange as Goya. Sudden and unexpected brilliance illuminates his work, touching on the highest themes of the human mind, which until then only the poet and the philosopher had attempted to convey. If in order to explain this we begin by supposing Goya was an intellectual, we shall have employed yet again the principle of the *virtus dormitiva*.

I would venture to go further: if this supposition gained weight, it would destroy the peculiar delight Goya gives us and which embraces all the rest of his art – the almost permanent struggle between the equivocal nature of his work and our own selves; faced with it, we do not know what we ought to think, whether it is good or bad, whether its meaning is one thing or perhaps the opposite, whether the creator likes what he does or does whatever comes forth without caring; in short, whether he

is a genius or a madman. If this vacillation should come to an end and we were able to make up our minds one way or the other, with it a highly personal pleasure would also be concluded for that unique thing in the history of art, Goya, would have ceased to be. But, luckily, a conclusion is never reached, the restlessness goes on perpetually – just as there is no end to the struggle between Ormazd and Ahriman, between the principles of good and evil. But the moment we feel determined to reject the dilemma once and for all is precisely the moment Goya waits for in order to take a further hold on us, binding us still closer to his magical world.

I do not see why the art historians do not declare more frankly what they *must* feel in the presence of Goya: namely, that he is an enigma, an immense riddle to be revealed if not solved. This means we must move slowly and forego simplifications, for simplifications have only served to complicate the matter still further, and one has to brush them aside to expose the true complexities that already exist. It is suspicious that the historians do not linger before the manual and mental torpor, the stupidity, indeed, the complete failures that exist among Goya's works. If a 'formidable intellectual level' – i.e., a clear and commanding mind – can be of any effect in painting, it is to give the artist a certain sureness in his work that eliminates at least the most serious lapses. To understand Goya is to explain not only what is good in him, but to make plain the causes of what is bad. But the hypothesis of a 'high intelligence' does not tally with his errors, neither does it serve to illuminate the origin of his finest qualities – not only his prodigious use of colour and the striking grace of his forms, but also that quality which transcends all the plastic arts and touches on spiritual mysteries. Nothing of this is reached by cerebration; they are things which elude thought. The truth is that Goya's oeuvre never germinates in the intellect; either it is common workmanship – or it is the vision of an inspired somnambulist.

Appendix

Extract from Ortega y Gasset's Introduction to Velazquez, 1954

THE SPINNERS

From a failure to define with precision Velazquez' attitude to mythological themes, his most important picture, *The Spinners*, which was also the last of his great compositions, has not been understood until recent years. Justi said it was the first painting to represent a workshop. The socialist bigotry of the beginning of this century accepted this version with fervour. As early as 1943 I expressed my conviction that the famous canvas was in fact of a mythological nature and that it perhaps represented the Fates. At that time I had no bibliographical means for determining the subject of the picture. It was Snr Angulo's ingenious idea that the painting referred to the legend of Pallas and Arachne which Ovid narrates in the *Metamorphoses*, found in Velazquez' library. Arachne, a great weaver of tapestries, insolently boasts of her skill to Pallas, who turns her into a spider. The luminous background of the picture, which is the culmination of Velazquez' art as a painter of light, corresponds to the Ovidian story, though in it there is one element which still cannot be explained: the cello or *viola di gamba*. To pursue Snr Angulo's theory, the two principal figures in the foreground might well be Pallas, in the guise of an old woman as she appears in Ovid's account, and Arachne, before the quarrel. But in fact these two women are not occupied in weaving, but in spinning. This would by no means be sufficient reason for thinking them the Fates, even allowing that at times only two of them might have been at work. When a mythological picture presents a somewhat unusual theme it is not enough to attend to the visible evidence it contains, but it is essential to find, as Snr Angulo has done, a Latin text which supports the interpretation. Now I recalled one which was like an *aria de bravura* among the humanists: the *Wedding of Thetis and Peleus*, which is the longest and most prudish of Catullus' poems. The scene is set before some tapestries which the young girls of Thessaly are contemplating. In front of those tapestries, the Fates sing their prophecies on the future of that illustrious marriage, and while they sing they spin: 'The left hand holds the distaff loaded with soft wool while the right hand lightly draws the wool and with it forms a thread which the curved fingers twist round while the bent thumb makes the round spindle turn. . . . At their feet lie the white locks of wool in small baskets of plaited rushes . . .' There is, by a singular coincidence, an atmosphere

135

of festivity and music in Velazquez' picture which accords well with Catullus' verses.

Here, in this painting done three years before his death, he avoids portraiture. None of the figures is individualized. The aged spinner on the left possesses only generic features and quite deliberately he has refused to show us the face of the younger spinner. Why these precautions? Without doubt to prevent any particular component from commanding our attention so that the painting as a whole may act upon the viewer. Should one look for a protagonist one would have to recognize that the sunlight streaming forth in the background has the principal role.

For the rest, the structure of the composition is the same as that of *Las Meninas* and *The Surrender of Breda*: an open-sided U in the foreground, embracing a middleground of great luminosity.

Selected Bibliography

Works by Ortega y Gasset currently in print in English translations
Concord and Liberty New York 1963
Dehumanization of Art and Other Essays in Art, Culture and Literature Princeton, NJ, 1969
History as a System New York 1941
Man and Crisis London 1959, New York 1958
Man and People New York 1963
Meditations on Quixote New York 1961
Mission of the University New York 1966
Modern Theme New York 1961
On Love: Aspects of a Single Theme London 1967
Origin of Philosophy New York 1967
Revolt of the Masses London 1951, New York 1957
Some Lessons in Metaphysics New York 1970
What is Philosophy New York 1961

On Ortega
Mora, J. Ferrater *Ortega y Gasset* London 1957

On Velazquez
Ferrari, Enrique Lafuente *Velazquez* London and New York 1960
López-Rey, José *Velazquez' Work and World* London and New York 1969
Mayer, August L. *Velazquez. A Catalogue Raisonné of the Pictures and Drawings* London 1936
Salas, Xavier de *Velazquez* London 1962
Stevenson, R.A.M. *The Art of Velazquez* 3rd ed., with biographical study by Denys Sutton and annotated by Theodore Crombie, London and Chester Springs, Pa., 1962
Troutman, Philip *Velazquez* London 1965

On Goya
Cantón, Francisco Javier Sánchez *Goya and the Black Paintings*, with appendix by Xavier de Salas, London 1964
Ferrari, Enrique Lafuente *Goya's Frescoes at San Antonio de la Florida* New York 1955
Gasseir, Pierre and Juliet Wilson *Goya* London and New York 1971
Harris, Enriqueta *Goya* London and New York 1969
Harris, Thomas *Goya: Engravings and Lithographs* Oxford 1964
Mayer, August L. *Francisco de Goya* London and New York 1924

Index